T3-BHN-120

# Color
# & Layout

**From
Asparagus White
to Burnt Olive**

# Color
# & Layout

**From
Asparagus White
to Burnt Olive**

**by Otto&Olaf
+ Nacho Martí**

COLLINS DESIGN
*An Imprint of HarperCollins Publishers*

COLOR & LAYOUT: FROM ASPARAGUS WHITE TO BURNT OLIVE
Copyright © 2008 COLLINS DESIGN and **maomao** publications

HarperCollins books may be purchased for educational, business, or sales promotional use.
For information, please write: Special Markets Department, HarperCollins*Publishers*,
10 East 53rd Street, New York, NY 10022.

English language edition first published in 2008 by:
Collins Design
*An Imprint* of HarperCollins*Publishers*
10 East 53rd Street
New York, NY 10022
Tel.: (212) 207-7000
Fax: (212) 207-7654
collinsdesign@harpercollins.com
www.harpercollins.com

Distributed throughout the world by:
HarperCollins*Publishers*
10 East 53rd Street
New York, NY 10022
Fax: (212) 207-7654

First Edition published by:
**maomao** publications in 2008
Tallers, 22 bis, 3º 1ª
08001 Barcelona, Spain
Tel.: +34 93 481 57 22
Fax: +34 93 317 42 08
mao@maomaopublications.com
www.maomaopublications.com

Editors:
Otto&Olaf
Nacho Martí

Art Direction, Design, and Illustrations:
Otto&Olaf
www.otto-olaf.com

Text:
Felipe Cano
felipe@otto-olaf.com

Translation:
Kevin Krell

Editorial Coordinator:
Anja Llorella

Library of Congress Control Number: 2008926855

ISBN: 978-0-06-153790-5

Printed in China

First Printing, 2008

Color Name

Project Name
Designer(s)
Website

Project and Color Description

If we said Pantone 100U, then probably only a few people would know what color we were talking about. However, when we say chick yellow, everybody has an idea of the kind of yellow we are referring to. And the fact is each color contains within it thousands of shades, objects, experiences and sensations that distinguish it from the rest. Each of us, even without knowing it, possesses a world and a memory of chromatic colors, preferences and phobias that become and help to explain our unique style and personality. *Color & Layout* takes a sensitive and poetic approach to this world through graphic works from across the globe: something along the lines of a personal chromatic guide in addition to being an X-ray of contemporary graphic design.

Just as the taste of an exquisite wine triggers in the palate of a connoisseur a plethora of references to different fruits, spices, meteorological phenomena, and even moods, the use of colors in these pages, far from aspiring to professional precision, represents an abstract and subjective look at how artists experience, relate to, and employ color in their work.

*Color & Layout* is a journey through the world of color, which is to say, nothing less than a journey through the world. Our aim, dear reader, is to stimulate your imagination and your creativity so that you will look around you and be able to say unhesitatingly that the green of your sofa is a melancholy Irish green or the red of your alarm clock is, of course, one of the cruelest of its kind.

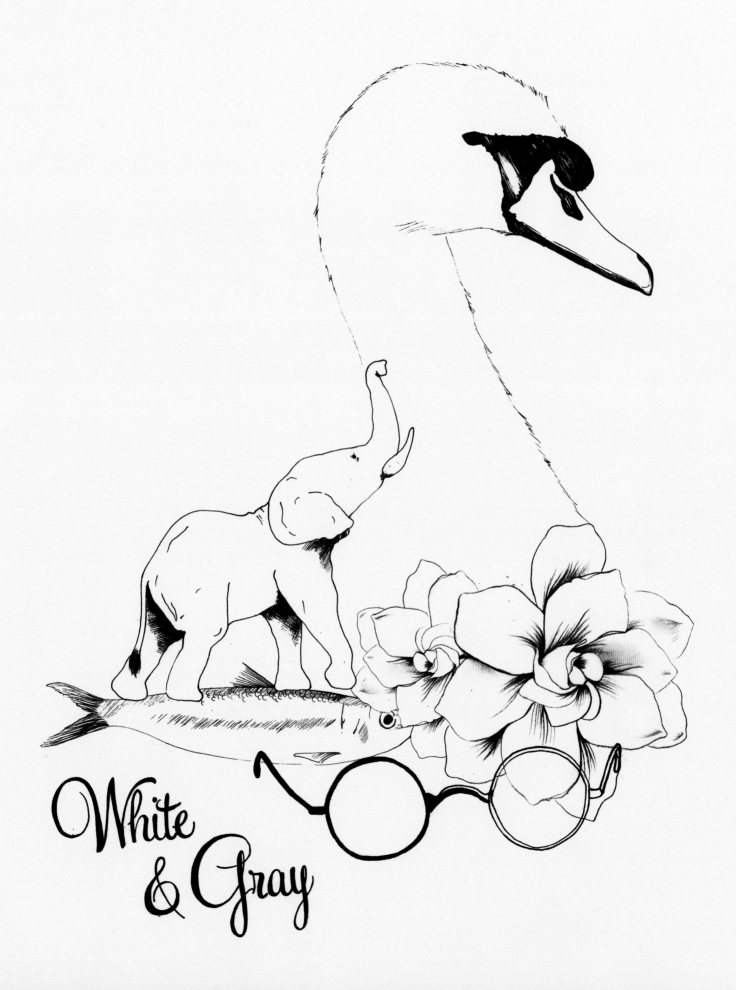

White
& Gray

Its reputation is divine. It is the color of the gods and heroes and light. Neither an inopportune word nor a disloyal act can be attributed to it. It is, without a doubt, the most important color, the sublimation of all others put together. Virtuous, pure, perfect, innocent . . . The synonyms are numerous, and no matter how hard one looks, they will find no antonyms to tarnish its reputation.

It comes as no surprise that it is standard-bearer of noble causes, of the most delicate feelings. Neither is it surprising that there are colors that grow bored with it and yawn when it begins to speak. For they know its story by heart: that it was adored in ancient Greece . . . that it clothes the swan, Gandhi, and Zeus . . . that it enwraps brides on the most important day of their lives . . . that it bids farewell to the dead in certain cultures . . . that it lends its name to millions of women throughout the world . . . that the Eskimos have forty different names for it . . . that it has always kept its figure and never put on even an ounce . . .

At this point in the monologue, Red cannot take it anymore and interrupts:

"And that cowards wave you when they wish to surrender to their enemies."

What usually follows is an argument between the two about the necessity or lack thereof of war. It would involve a lengthy transcription, yet can be summed up in the following terms. Red thinks White is a dull, pedantic pacifist, and White thinks Red is a dangerous war-like troublemaker.

It has a high-pitched voice, smells like incense, is an untiring reader of Greek philosophy, and a fan of the early Beatles.

Its most famous statement: "Let there be light."

\*

Sometimes it is the case—although it seems impossible if we keep in mind the reputation of both—that when Black and White mix, unite, fuse, dilute, join, rejoin, get shuffled, come together again, are watered down, tangled, muddled, shaken up, become interwoven, unravel, link up, cool down . . . Gray is born.

Asparagus White

Paper Tiger

Glamorous Light

White Light

Sugar Cane

Recycled Paper

Fake Pirates

White Braille

Urban White

Elephant Skin

More than White

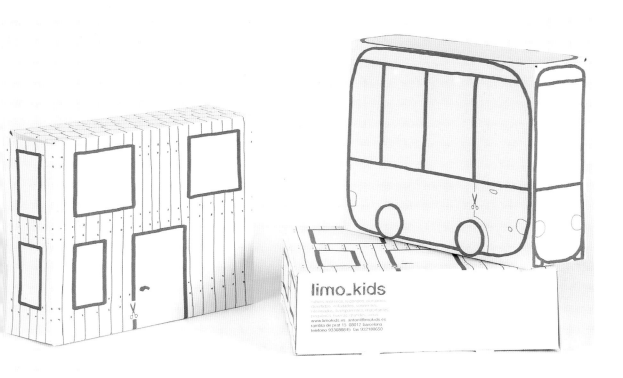

limo_kids

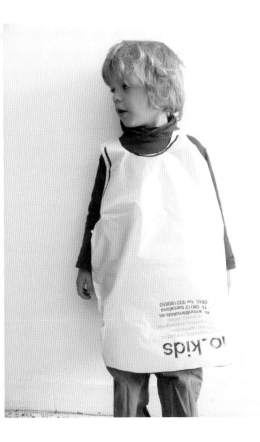

Asparagus White

limokids
Emeyele
www.emeyele.com

limokids is a clothing and items
shop for children ages one to five.
Its corporate image is created with
recycled material in black and white.
The aim of the establishment is to
introduce children to the world of
recycling.

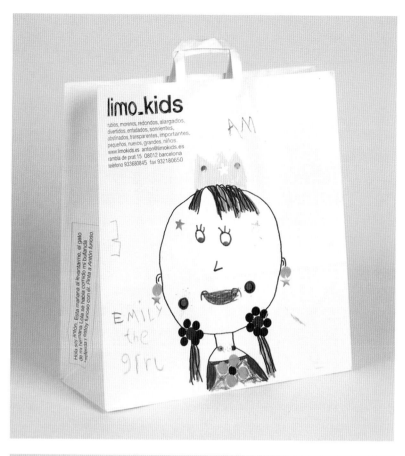

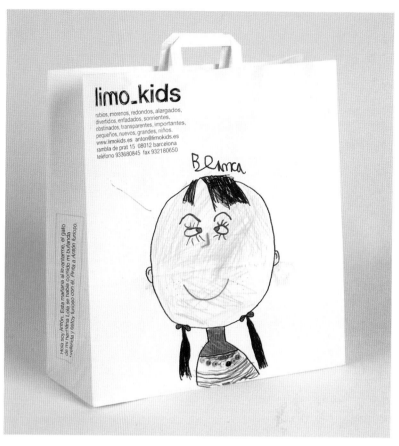

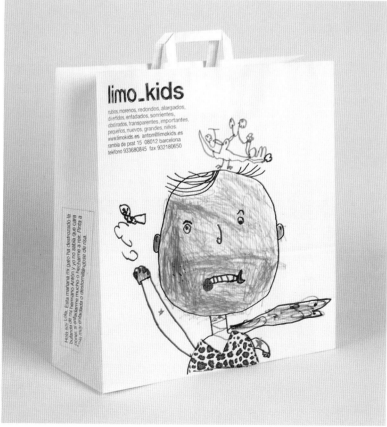

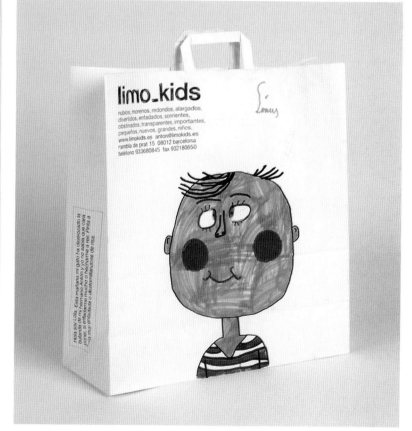

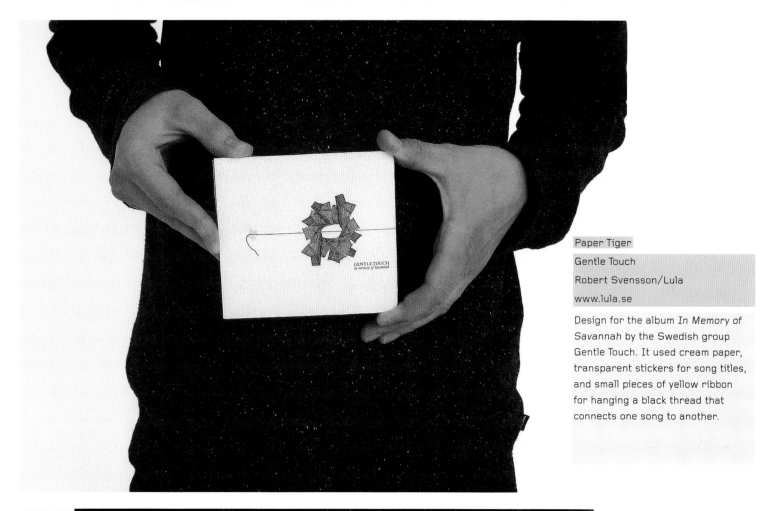

Paper Tiger

Gentle Touch

Robert Svensson/Lula

www.lula.se

Design for the album *In Memory of Savannah* by the Swedish group Gentle Touch. It used cream paper, transparent stickers for song titles, and small pieces of yellow ribbon for hanging a black thread that connects one song to another.

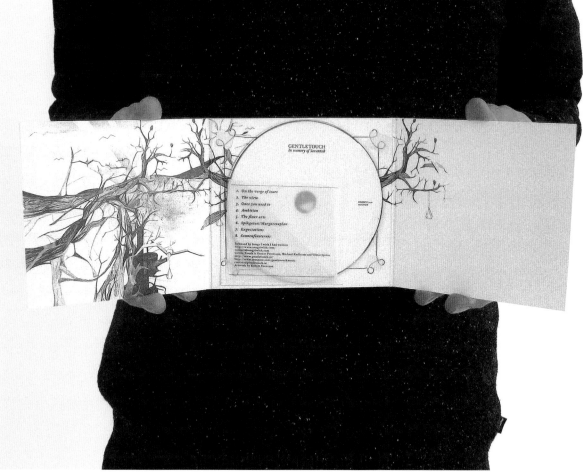

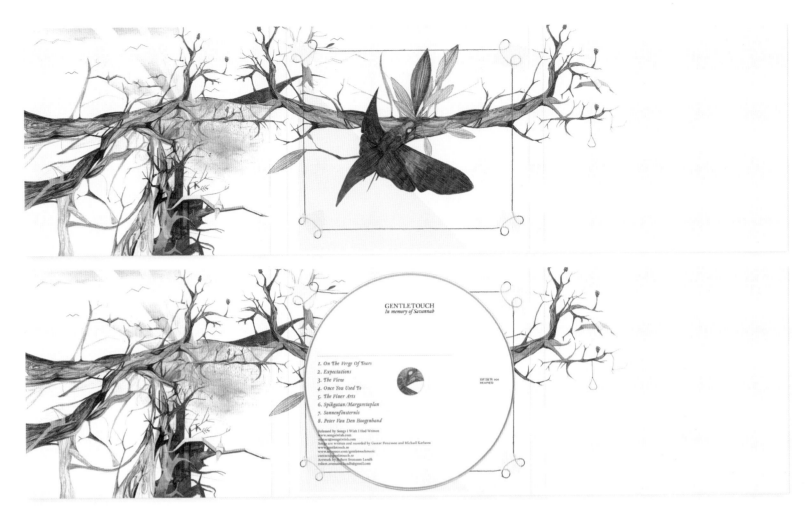

Pedro garcía

garcía
o alto, c/italia 46
a-alicante/españa
539 90 07
rogarcia.com
rogarcia.com

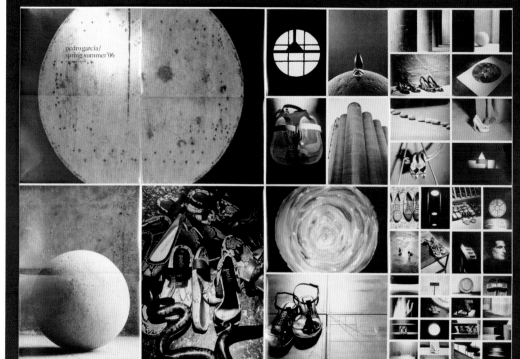

pedro garcía/
spring summer'06

Glamorous Light

Pedro García
Daniel Ayuso/Cla-se
www.cla-se.com

New image of footwear brand Pedro
García. The new image is based
on the development of an original
graphic system created with Caslon
540 typography and the chromatic
use of black and white.

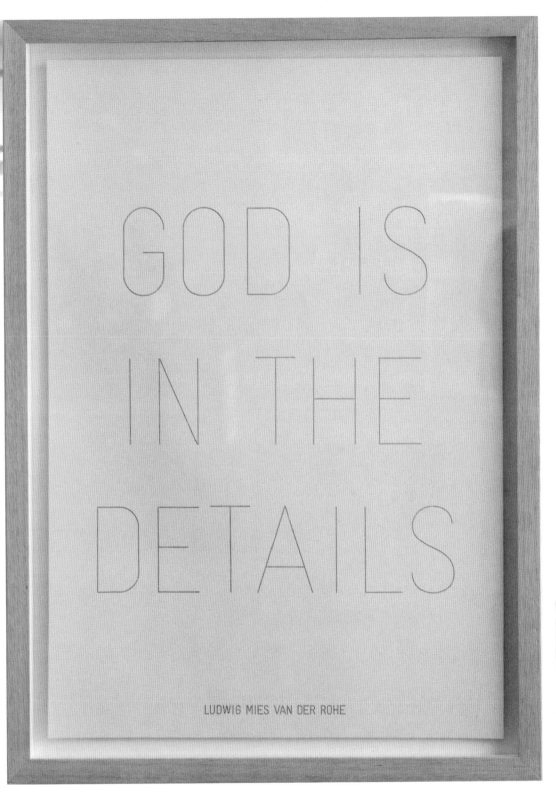

White Light

God Is in the Details

James Musgrave

www.jamesmusgrave.com

Tribute to Ludwig Mies van der Rohe. This work takes inspiration in the purity of white and the way it can accentuate the elegance of details through an apparently simple creative process.

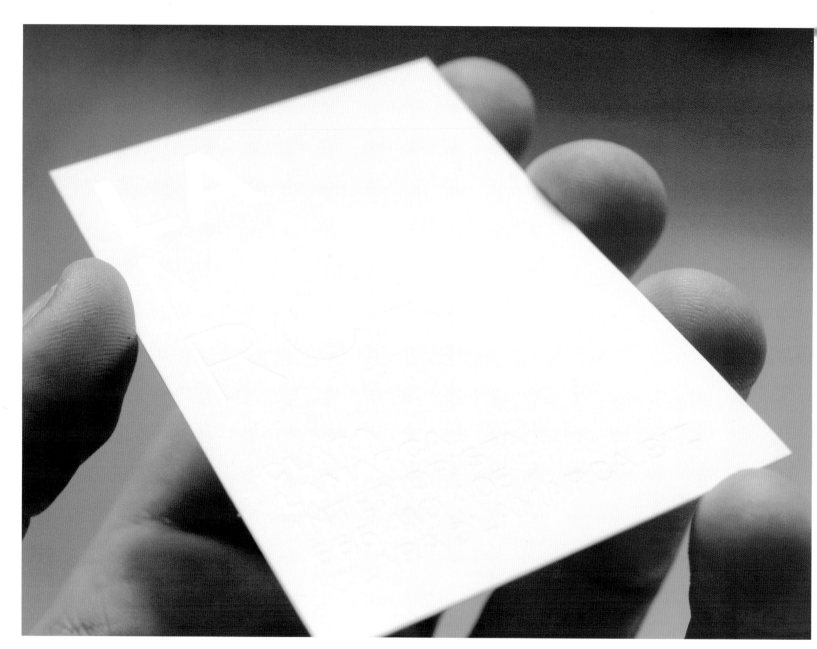

Sugar Cane

Clara Lamarca

Borja Martínez/LoSiento

www.losiento.net

Corporate image for an interior
designer. The stationery is created
with stamping, without the use of
ink. The interior designer tends
to use a pencil for shading in the
information on the card and thus
improving its legibility.

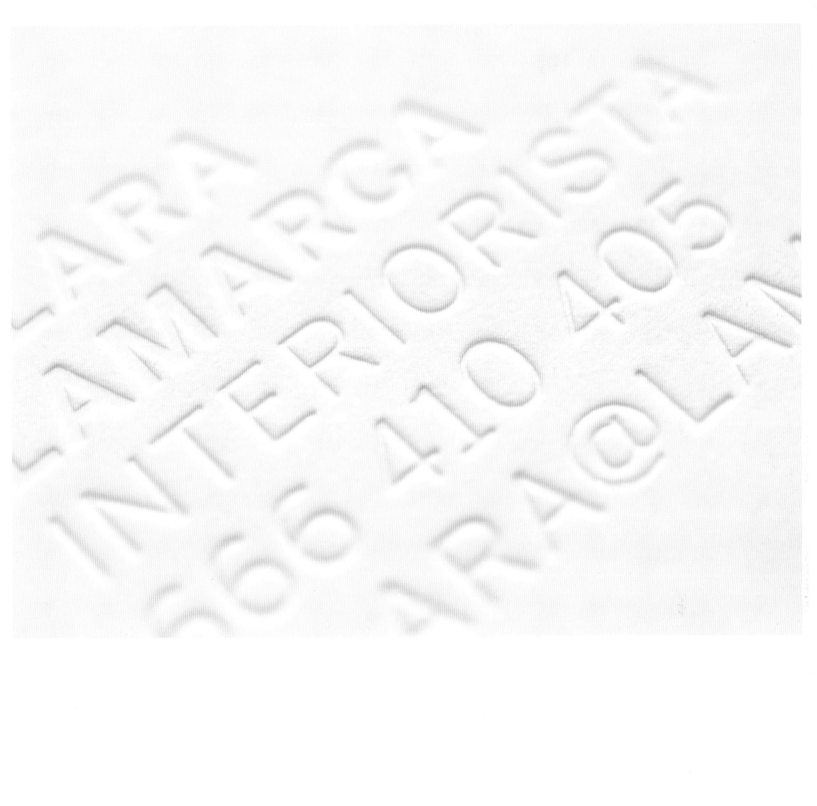

Recycled Paper

Buttercup Metal Polish

Alban Thomas, Gérald Moulière,

Hervé Rigal/GVA Studio

www.gvastudio.com

CD case of a contemporary music group. The white letters are printed on rough cardboard. The combination of the printing process, color, typography and the object go very well with the musical project.

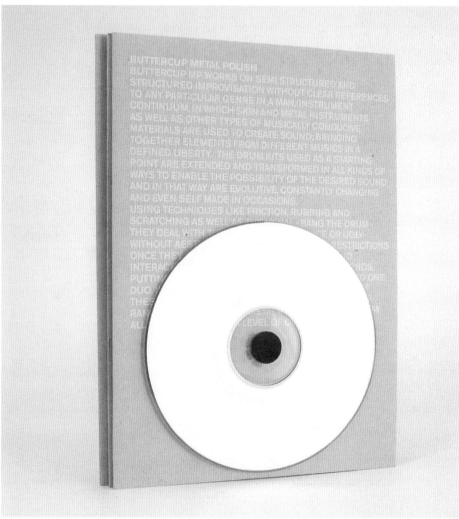

Fake Pirates

Business Cards
Maria Escuer/Dominio Público
www.dominio-publico.org

Business cards in which solely black
ink was used to create a timeless
quality. Influential in the design was
the idea of calling attention not only
to the name and occupation of its
holder, but also to their personality.

JUAN STUDIO GÓSOL, 17 SOT.1ª 08017 BARCELONA T./F. 93 280 39 85 JVFOTOGRAFIA@JAZZFREE.COM

alba suñé foto
grafía t 93 211
48 91 m 63 63
11 865 albasu
ne@orange.es

http://www.somelabs.org
some@somelabs.org

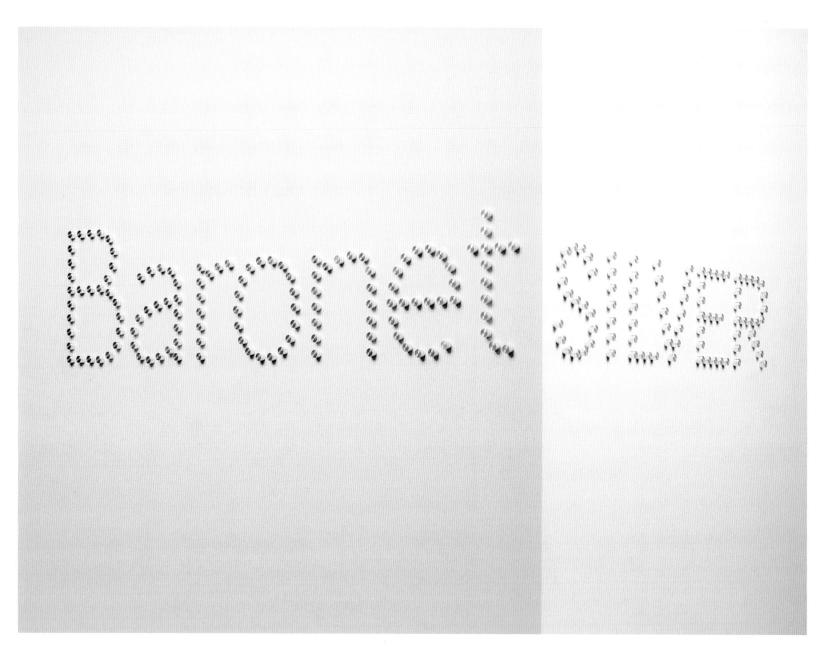

White Braille

Baronet
René Clement/Paprika
www.paprika.com

Here the most is made of the
elegance of white in the stationery
merchandise of this Canadian store.
Being a stationery store, it was
imperative to call attention to the
white color of the paper, except
for the name Baronet and the logo,
highlighted in black.

234, rue **Baronet**, C.P. 580
Sainte-Marie (Québec)
Canada G6E 3B8
T. 418 387-5431
F. 418 386-4427
http://www.baronet.ca

Ivan L. Lacroix
ilacroix@baronet.ca

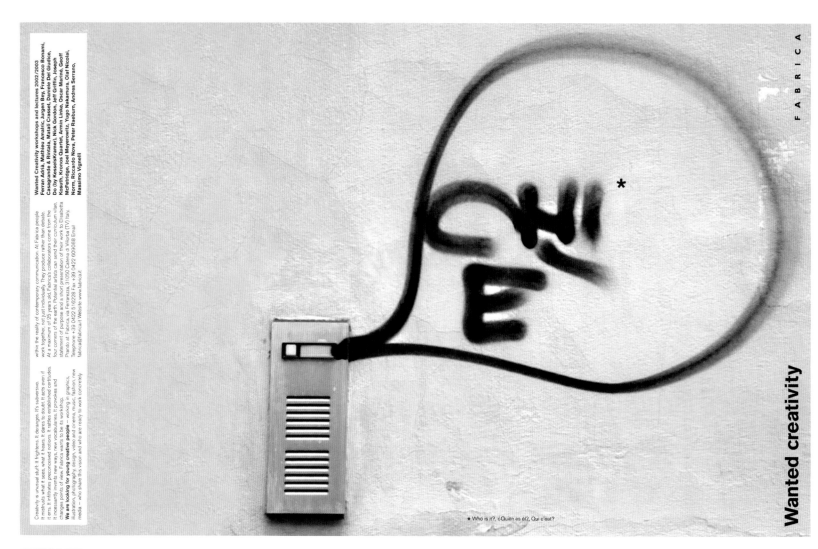

Urban White

Who Is it?

Craig Holden Feinberg/Begson

www.begson.com

Double page for issue 57 of *Colors Magazine*. The theme was poor neighborhoods. The author took a photograph during a trip to Rome of an intercom and the accompanying graffiti "Who is it?" sprayed inside a speech bubble.

17:35:23

17:35:24

Elephant Skin
Mar de grises
Anton Molina/SCPF
www.scpf.com

For the author of this book, nothing
is absolutely white or black. A lead-
gray afternoon at the Concha beach
in Donostia under a deep sea of
gray serves to illustrate the author's
thesis: the passage of time and life's
changes.

**LE BOOK EMISSAIRE**

Introduction à un concours des plus beaux livres
Alexandre Chapus
Novembre 2006

More than White

*Le Book Emissaire*

Denastas & Chapus

www.denastasetchapus.com

Book printed totally in white and black. An important part of this compilation project consisted in presenting and showing examples of books that shared the same characteristics.

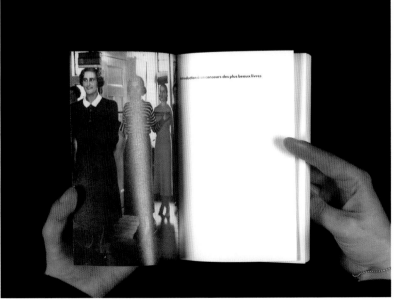

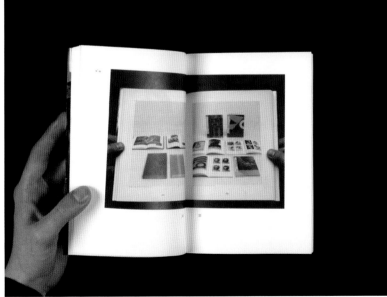

# From Pacman
## to Yellow Smiley

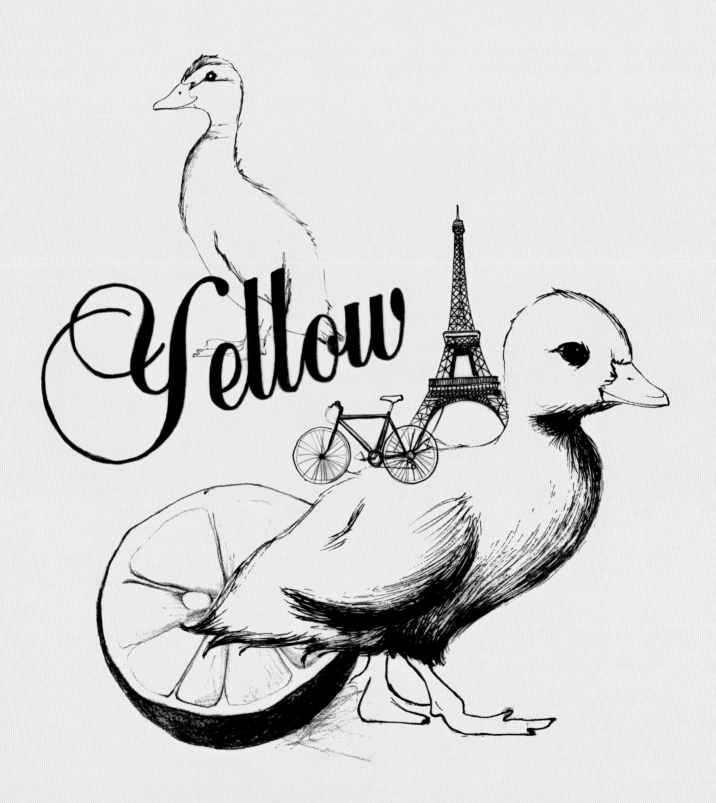

Yellow

It is born and dies every day. Each morning it is a child and each afternoon an old man. And in the passage from one to the other, Yellow embraces all the feelings, all the virtues, all the flaws.

In the morning: fun, optimism, kindness.
At midday: betrayal, passion, madness.
In the afternoon: creativity, maturity, reflection.

The speed of its life cycle causes nobody to really know what to make of it. Contradiction is always frightening, and it is pure contradiction. In the world of art, however, it has great admirers. The most well known was a man also adrift in the hours and the days; a redhead with stunned eyes who searched for Yellow in the Midi French countryside: Vincent van Gogh. When it gazes at the paintings of the ill-fated painter, it feels an intimate gratitude. Still, it was unmoved by the pronouncement of the Bauhaus school: "Yellow is triangular in form." If you say so, it thought, and continued on its way.

It lives apart from criticism and praise. It doesn't have time for one or the other. It walks with its head held high, not out of vanity but out of a hunger for light; and it is always biting its nails, what betrays its lack of etiquette.

It has the high-pitched voice of querulous old ladies.

Every year, on the Champs Elysées, it hides among the crowd in order to enjoy the finish of the Tour de France. It likes the moment when the winner puts on the yellow jersey. It is its way of compensating for the scant sympathy that the world of theater shows it.

It is no surprise then that it likes sports, but not reading. It does enjoy cinema, though, especially *Lawrence of Arabia* by David Lean.

Its most famous statement: "The future is yellow, but it's not such a big deal."

Pacman

Sunny Day

Duck

Canary

Deutsche Post

Cold Lemonade

Vibrant Yellow

Dangerous Yellow

Acid Lemon

Sparkling Yellow

Candle Light

Post-it Yellow

Banana Split

Yellow Scotch-tape

Yellow Brick

Neon Yellow

Yellow Smiley

# 奇妙で、同等です。

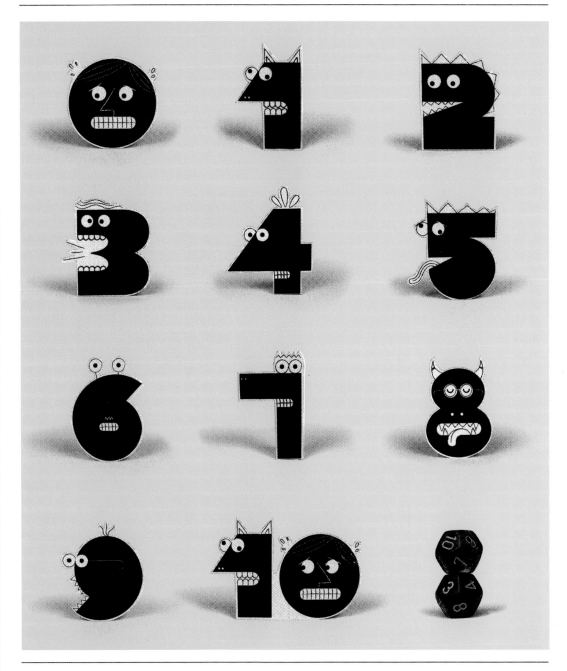

Pacman

**Odd or Even**

Steven Harrington

www.stevenharrington.com

Dark brown and yellow combine in this design in such a way that it seems like a wrapper. This work formed part of the Cody Hudson exhibition *We're Rollin' They're Hatin'*, an extensive representation of contemporary art.

捨て札をセットすることで多少の基本的な心の数学が助けます。手を半端な番号を付けられていさえしたタイルに分けてください。10の倍数は偶数で、そのような数の法律はそれを私たちに話します： =(均衡がとれて、+均衡がとれて、+均衡がとれる) 10(奇妙であること+奇妙であること)の同等の可能な倍数か(半端で、+半端である、+半端な)　奇妙である　あるいは　(同等で、+同等で、+奇妙で)=奇妙である。もし手が5枚の半端な番号を付けられたタイルを持っていれば、あなたは捨てることができません。もしあなたの手が4枚の半端な番号を付けられたタイルを持っていれば、同等の番号を付けられたタイルから始めることによって捨て札を捜して、他の2つをそれに加えてください。もしあなたの手が3枚の半端な番号を付けられたタイルを持っていれば、(半端で、+半端である、+同等の)組み合わせの捨て札を捜してください。もしあなたの手が2枚の半端な番号を付けられたタイルを持っていれば、それらとの捨て札と同等の番号を付けられたタイルの1枚を捜してください。このために3枚の同等の番号を付けられたタイルへの一覧　あなたの手が1枚の半端な番号を付けられたタイルを持っている　そしてそれをひっくり返るように変えて、捨て札を捜す　残りの4、で、あなたの手が半端な番号を付けられたタイルを持っていない　そして残りの5枚のタイルの捨て札を捜す。

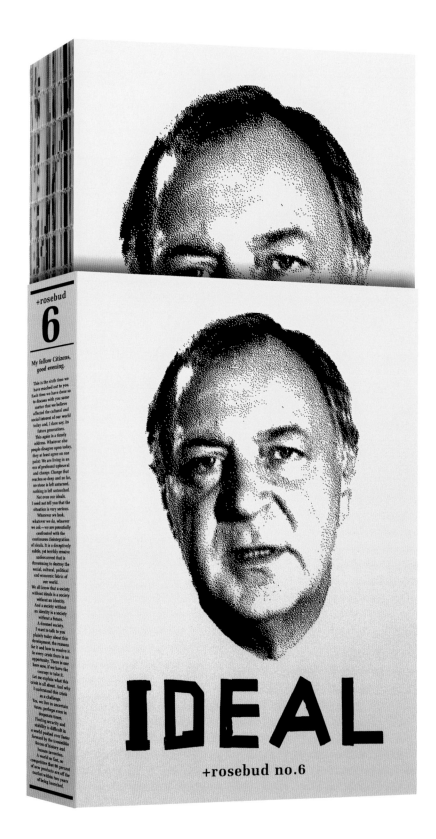

Sunny Day

*Ideal*

Ralf Herms, Katja Fössel, Fritz T.

Magistris/Rosebud, Inc.

www.rosebud-inc.com

*Rosebud* is a design magazine that explores the possibilities that paper, with its 2D nature, can offer. *Ideal* offers a look toward the future, utilizing to this end an energetic yellow on the cover.

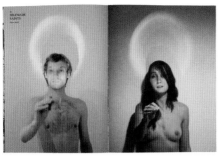

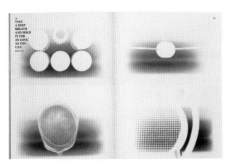

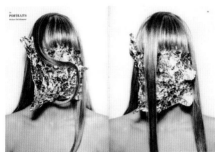

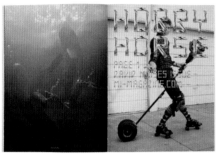

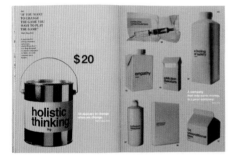

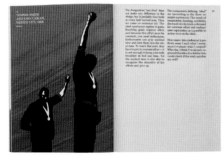

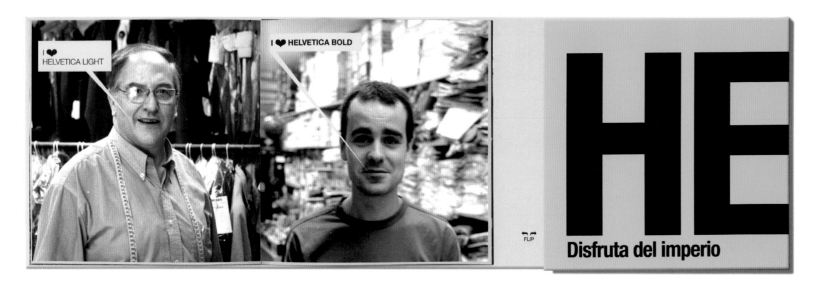

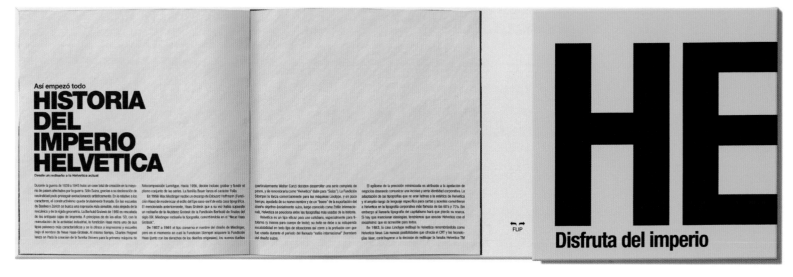

Duck

Helvetica

Santi Grau/La Taca Gràfica Editorial

www.latacagrafica.com

Tribute to Helvetica typography as a
quality creation, despite the gradual
and unmerited oblivion into which
it has fallen. Yellow contrasts with
black and white photographs of
natural landscapes.

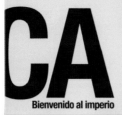
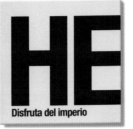

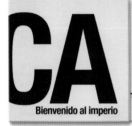
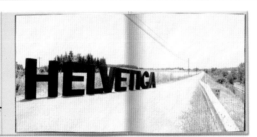

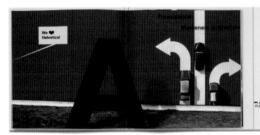

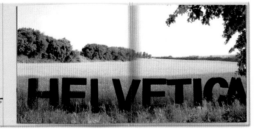

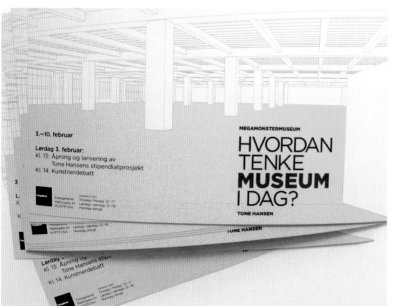

Canary

*Megamonstermuseum: Hvordan Tenke Museum I Dag?*

Claudia

www.claudia.as

The colors of the title and the beginning of this book by Tone Hansen come from various museums. Yellow represents newness and audacity, two necessary qualities, according to Hansen, for a museum to have a personality of its own.

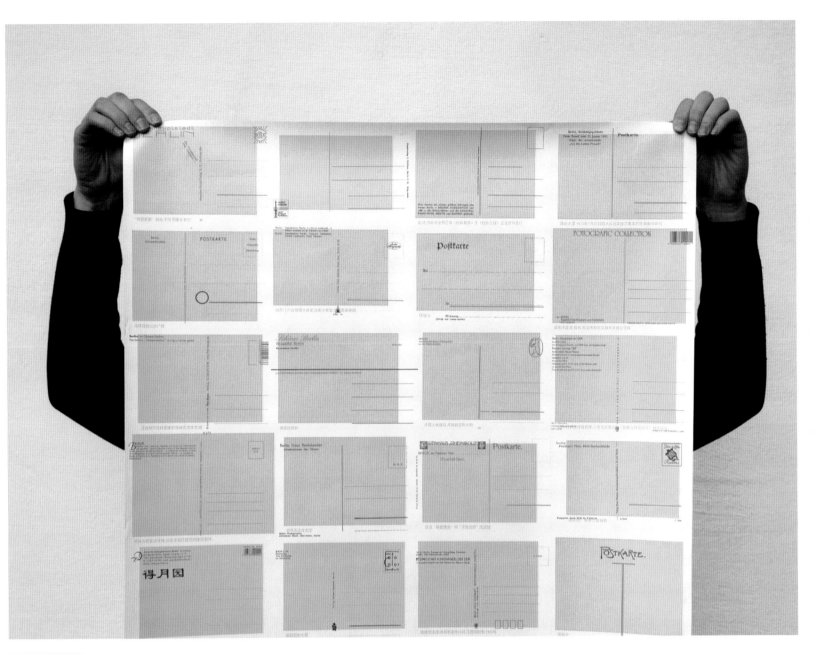

Deutsche Post

What Makes Berlin Addictive
Hofgaard, Llovet Casademont,
Rompza/NODE Berlin Oslo
www.nodeberlin.com

Poster for an exhibition in Shanghai
that had the image of Berlin as
an introduction. This work is the
answer to the question: "What
makes Berlin addictive?" The yellow
of the Deutsche Post was selected
for its broad and nervous quality.

Cold Lemonade

*Hundertmal im Schtei*

Erich Brechbühl/Mixer

www.mixer.ch

Book that gathers together 100 first edition posters, out of a total of 113 since 1997, from the concert hall im Schtei, located intriguingly in a Swiss cave. Acid yellow is the color base for them all.

Titel **Hundertmal im Schtei**

Gestalter **Erich Brechbühl** Verlag **Martin Wallimann** ISBN **3-908713-63-3**

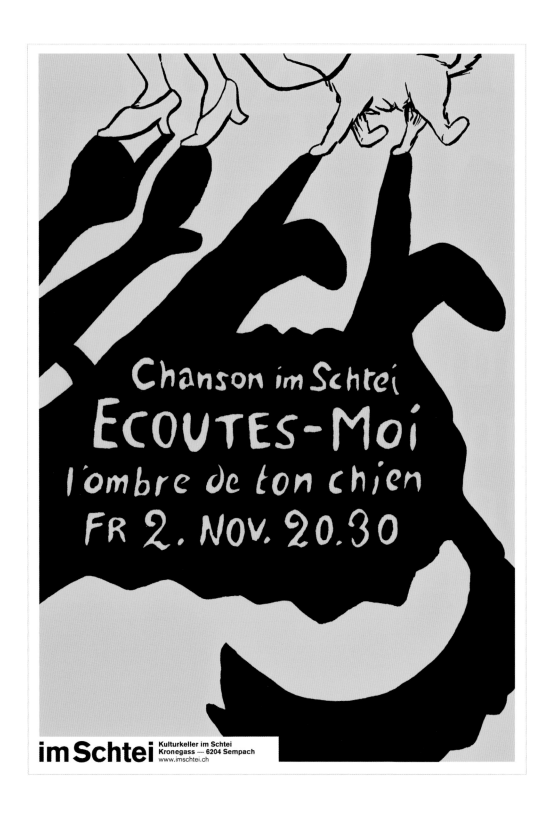

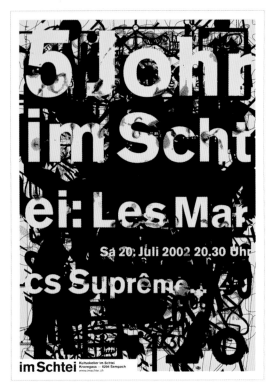

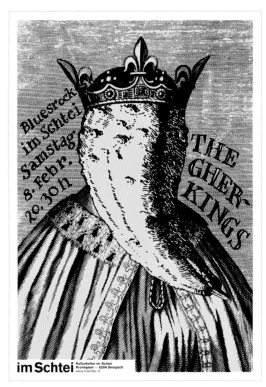

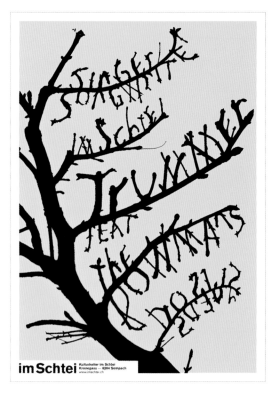

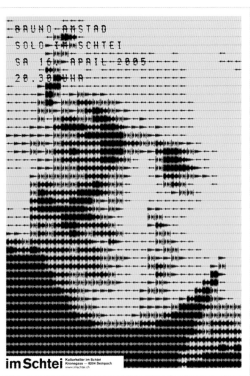

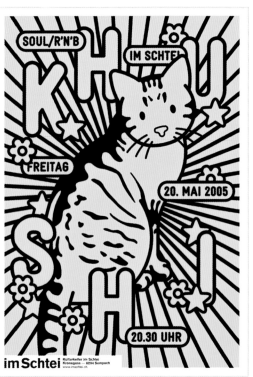

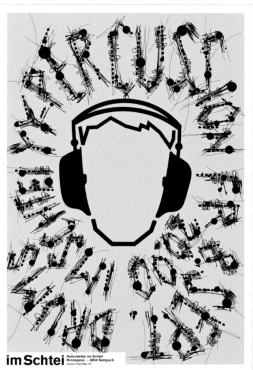

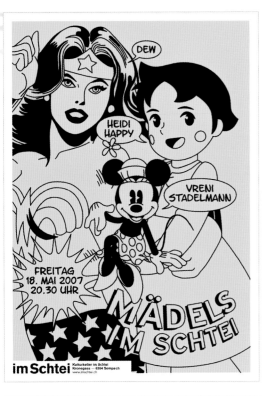

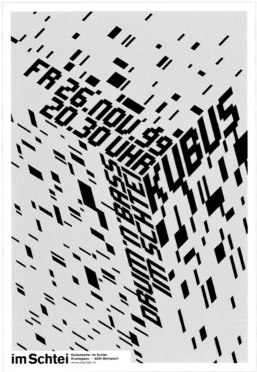

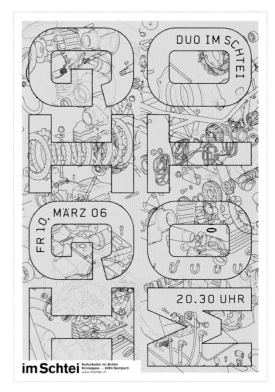

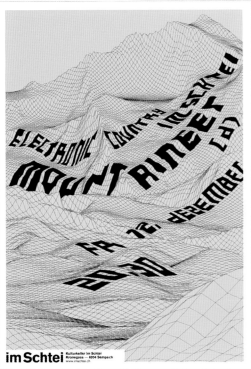

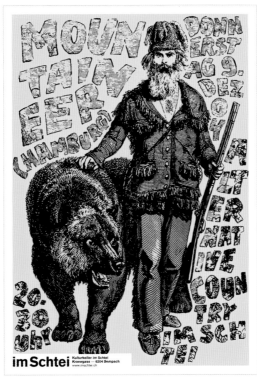

**Vibrant Yellow**

London Underground Posters
Thorbjørn Ankerstjerne
www.ankerstjerne.co.uk

Series of posters that represent
and highlight the characteristic
yellow line painted on the floor
of the London metro. This sign
indicates the caution zone on station
platforms.

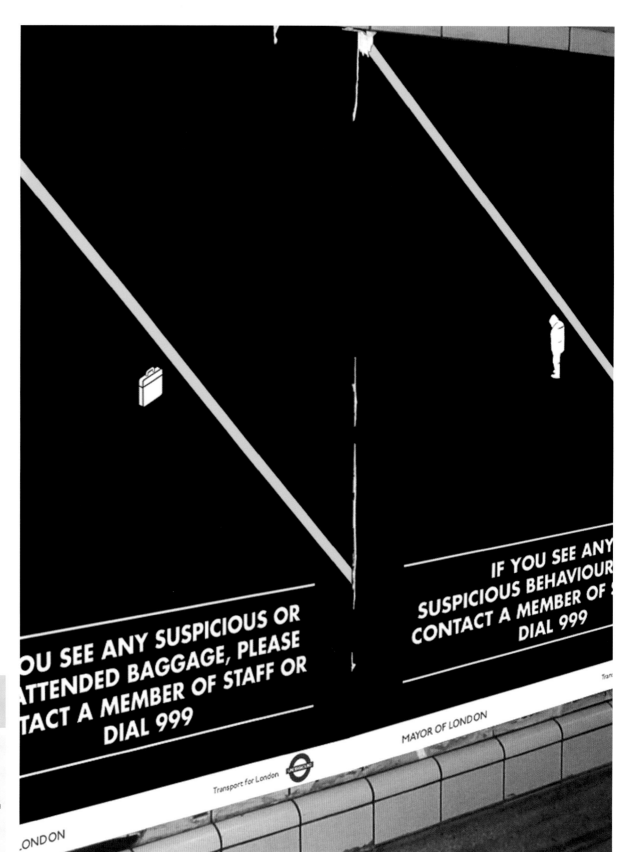

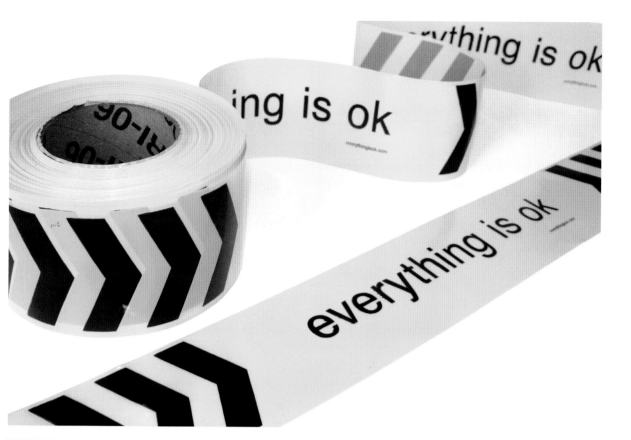

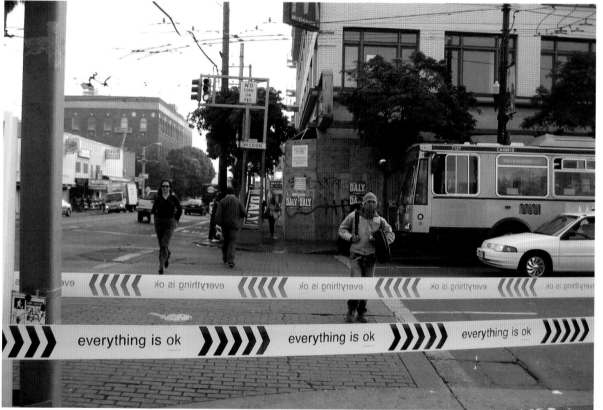

**Dangerous Yellow**

Everything Is OK
Christopher Simmons, Tim Belonax/
MINE
www.minesf.com

Public and interactive design
experiment. The phrase "everything
is ok" was printed on the traditional
yellow and black caution tape
to underscore the irony of the
message.

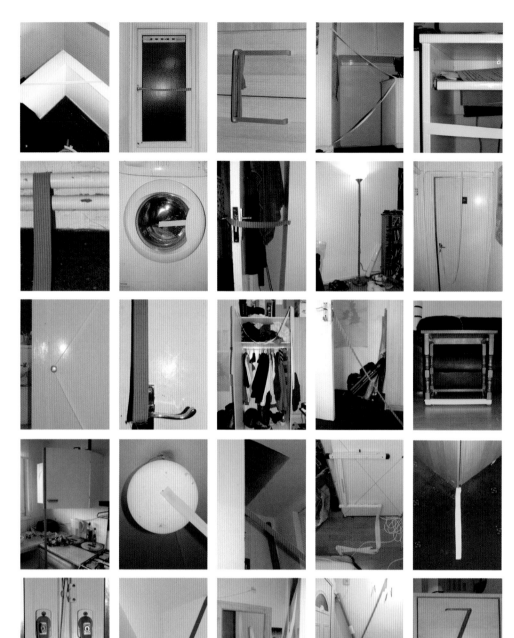

Acid Lemon

Seven Jenkinson Typeface
Matt Bucknall
www.mattbucknall.co.uk

A series of brilliant and fluorescent colors used here in contrast with the colors of the house. The characters, from A to Z, were conceived with the idea of creating a "homemade" typography.

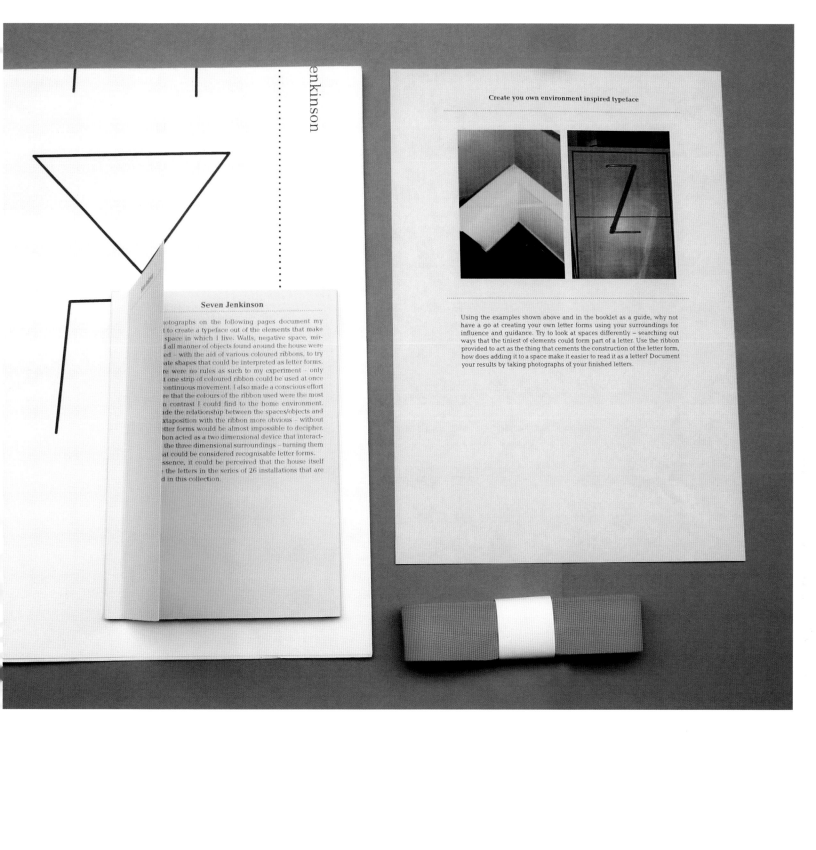

**Seven Jenkinson**

...otographs on the following pages document my
...t to create a typeface out of the elements that make
... space in which I live. Walls, negative space, mir-
...d all manner of objects found around the house were
...ed – with the aid of various coloured ribbons, to try
...ate shapes that could be interpreted as letter forms.
...re were no rules as such to my experiment – only
...t one strip of coloured ribbon could be used at once
...ontinuous movement. I also made a conscious effort
...re that the colours of the ribbon used were the most
...n contrast I could find to the home environment.
...de the relationship between the spaces/objects and
...xtaposition with the ribbon more obvious – without
...etter forms would be almost impossible to decipher.
...bon acted as a two dimensional device that interact-
... the three dimensional surroundings – turning them
...at could be considered recognisable letter forms.
...ssence, it could be perceived that the house itself
...e the letters in the series of 26 installations that are
...d in this collection.

**Create you own environment inspired typeface**

Using the examples shown above and in the booklet as a guide, why not
have a go at creating your own letter forms using your surroundings for
influence and guidance. Try to look at spaces differently – searching out
ways that the tiniest of elements could form part of a letter. Use the ribbon
provided to act as the thing that cements the construction of the letter form,
how does adding it to a space make it easier to read it as a letter? Document
your results by taking photographs of your finished letters.

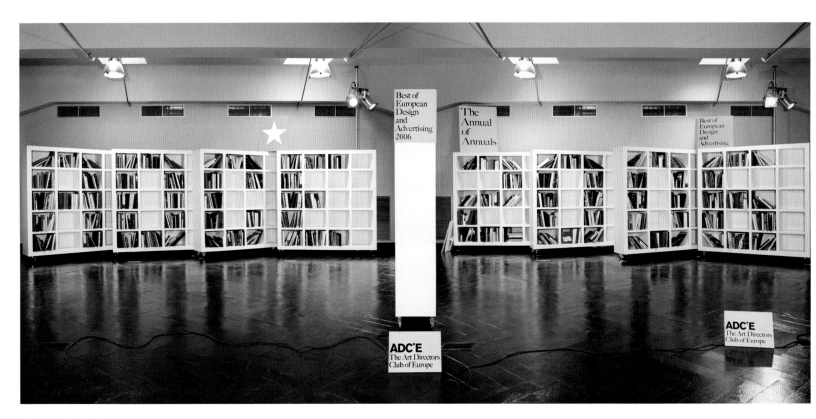

Sparkling Yellow

ADC*E

Marc Català, Pablo Juncadella/Mucho

www.mucho.ws

Cover for a book structured around
an alphabet made with yearbook
designs. The idea comes from the
yearbook ADC*E. Letter-shaped
bookcases on wheels was designed,
and after being filled with books,
still life photographs of the alphabet
were taken.

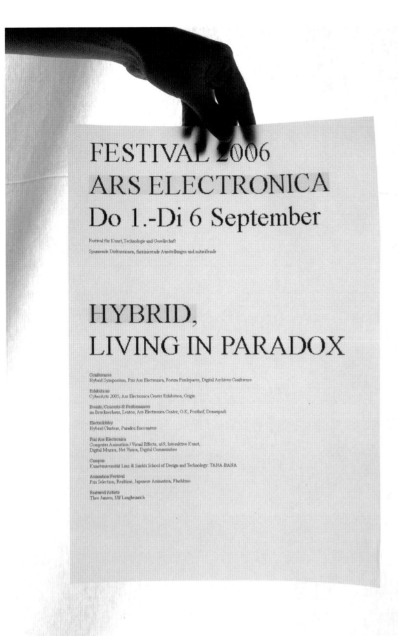

Candle Light

Times AE Screen

Miquel Polidano

www.miquelpolidano.com

Typographic creation of the 2006 edition of the Ars Electronica Festival, *Hybrid, Living in Paradox*. The conjunction of the highlighted yellows and translucent paper interacts with the white background.

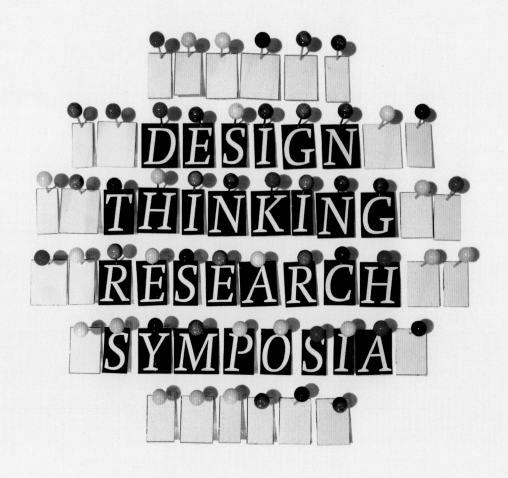

19th – 21st September 2007
Central Saint Martins College of Art and Design

DTRS

University of the
Arts London
Central
Saint Martins

**Post-it Yellow**

Design Thinking Research
Symposia (DTRS)
Thorbjørn Ankerstjerne
www.ankerstjerne.co.uk

Corporate image of the conference
organized by The Open University
in Central Saint Martins College of
Art and Design in the fall of 2007.
Yellow and black grab the viewer's
attention.

…was initiated by Nigel Cross with Norbert Roozer… The Netherlands, in 1991, with what was initiall… Research in Design Thinking'. But the content…

…94, focused on the use of protocol analysis as a research tool f… meeting was held at the Istanbul Technical University, Turkey, ir… …els of design, and the fourth meeting was held at the Massachus… …on, USA, in 1999, on the topic of design representation. It was…

…was again in Delft, in 2001, on the topic of design in context.

…most recent meeting, at the University of Technology, Sydney, Aus… …re near the focus of the original meeting in Delft in 1991, on the na…

…researchers for a workshop meeting to review the state of the… …ghout this series of symposia, this workshop format has been fo… …sising the contributions of an international community, of repor… …d promoting necessary further research.

' of

ne
elft,

ve

eet-

f

ip-

et-

DTRS

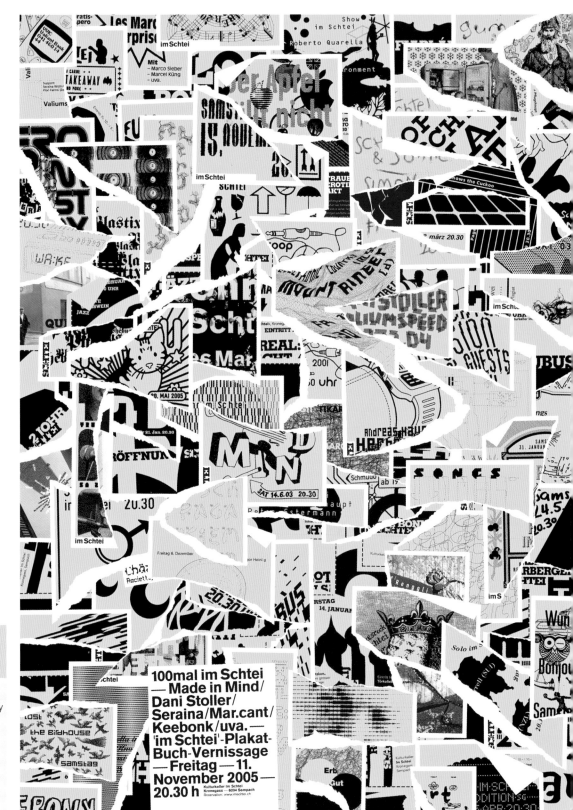

**Banana Split**

100 Best Posters '06

Erich Brechbühl/Mixer

www.mixer.ch

Design for the 2006 edition of the
100 Best Posters Contest—Germany
Austria Switzerland. Created with
bits and pieces of some of the
winning posters. Yellow is used for
the background and black for the
illustrations.

# MUZIEK UIT HET LAB

## MUZIEKLAB BRABANT

**2004**

**PARADOX - TILBURG,** DO. 8 JAN./
DO. 12 FEB./DO. 11 MRT./DO. 8 APR./
DO. 13 MEI
**HET MUZIEKCENTRUM -**
**'S-HERTOGENBOSCH,** DI. 13 JAN./
DI. 3 FEB./DI. 2 MRT./DI. 27 APR./
DI. 25 MEI
**ZESDE KOLONNE - EINDHOVEN,**
WO. 14 JAN./WO. 11 FEB./WO. 10 MRT./
WO. 14 APR/WO. 12 MEI
**LOKAAL 01 - BREDA,** VR. 13 FEB./
VR. 12 MRT./VR. 16 APR./VR. 14 MEI
20:30 UUR/21:00 UUR/21:30 UUR
TOEGANG GRATIS/TOEGANG:
5 EURO, STUDENTEN & CJP 2,50 EURO

ML B

Yellow Scotch-tape

Muziek uit het Lab

Hans Gremmen

www.hansgremmen.nl

Posters for an event organized by
the production company Muziek uit
het Lab. The annual program is held
at four locations. Using Scotch-tape
of four different colors, a distinction
is made between each location.

**Yellow Brick**

Our Geometric Family

Steven Harrington

www.stevenharrington.com

This piece is a four-page story designed for *Anorak* magazine. The story explores the role of primary colors and simple geometric forms in the world today, presented in an educational and straightforward manner.

Neon Yellow

Business Card (Self-promotion)

Stefanie Weigler/Triboro

www.triborodesign.com

Calling card. A color neither too strong nor too dark was selected. Neon yellow is fresh and bright. The letters are of an original typography that, along with the color, matches the initial idea to a tee.

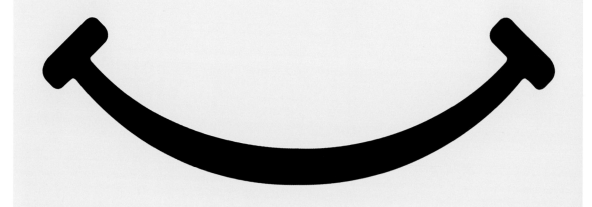

Breakbeat.is & Heineken kynna: OLD SKOOL Laugardaginn 11. júní frá kl. 24:00 á Gauknum, Tryggvagötu. Maggi Lego, Frímann Psycho, Bjössi Brunahani. 500 krónur til kl. 02:00. 1000 krónur eftir kl. 02:00. 20 ára aldurstakmark.

★ **Heineken**

Yellow Smiley

*Old Skool*

Ragnar Freyr

www.ragnarfreyr.com

Poster for the event Old Skool Breakbeat, which pays homage to the nineties musical genre breakbeat through one of its most famous icons, the yellow smile. The eyes of the poster were eliminated in order to encourage people to draw on it and finish it themselves.

# From Orange Marmalade
## to Dry Leaves

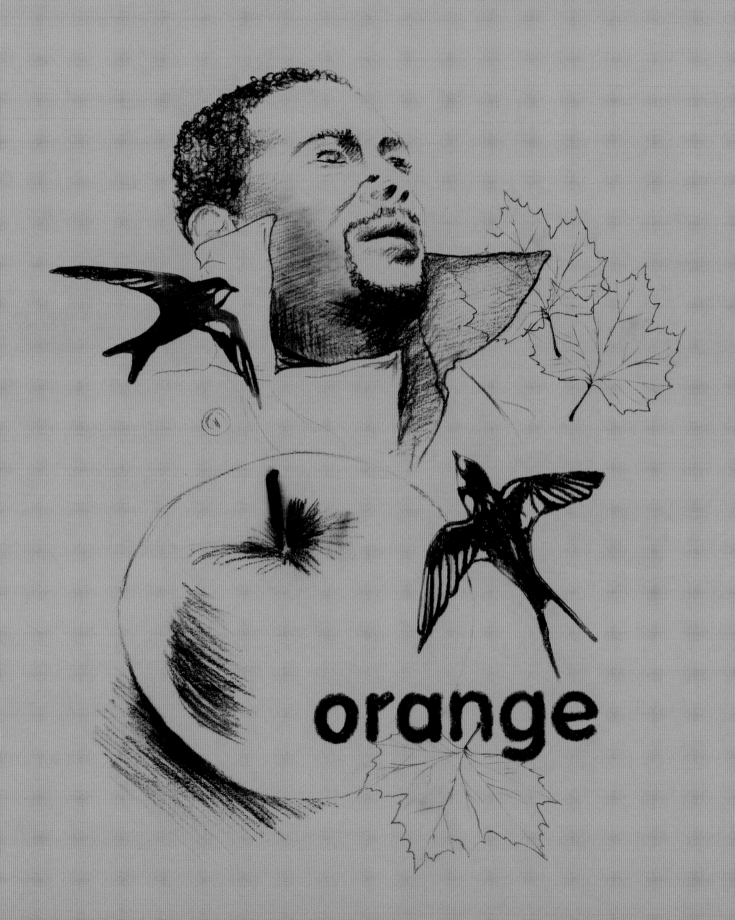

orange

Fruit of the union of fire and light, Orange is far from being the deity that everybody expected. Its occupation is to go unnoticed. It is modest and would like to be invisible. With time, it has achieved small triumphs: hair, cats, and Red sunsets that in reality are Orange. It thinks ambiguity is a good thing.

It walks with its head down, among autumnal or spring landscapes. It is unsettled by excessive heat and flees the cold with the speed of swallows.

It tends to inspire pity, something which it does not understand, because in its own way it is happy. It has always felt like a stranger wherever it is. It prefers solitude to the company of others and the world of sensations to a life of action. It is content with what it has and, in fact, would like to have less.

Its memory for tastes and smells is extraordinary. Whoever has heard it describe the excellent qualities of a fruit or a good wine will never forget it. Each word it utters is exact, irreplaceable, definitive, as if one could taste the mild acidity of the apple or the patient sweetness of the wine . . .

Certain company, however, causes it to glow with blinding intensity: Blue. Sometimes the Great Color takes pity on the prodigal son and surrounds it, envelops it, holds it tight, embraces him . . . And when this happens both experience a kind of intense communion.

It is a reader of Confucius and the Stoics. It likes chamber music and also Marvin Gaye, and, strangely enough, has never been to Holland.

Its most famous statement: "It's more than enough."

Orange Marmalade

Mandarine

Saffron

Vermillion

Gold Sunshine

Apricot

Persimmon Orange

Butane

Harvest Pumpkin

Dry Leaves

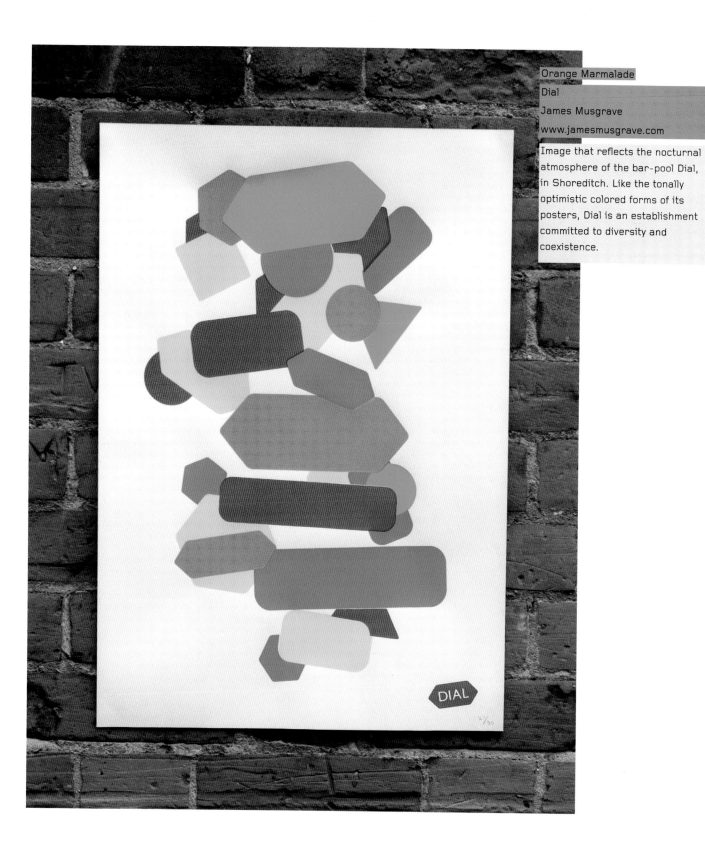

Orange Marmalade

Dial

James Musgrave

www.jamesmusgrave.com

Image that reflects the nocturnal atmosphere of the bar-pool Dial, in Shoreditch. Like the tonally optimistic colored forms of its posters, Dial is an establishment committed to diversity and coexistence.

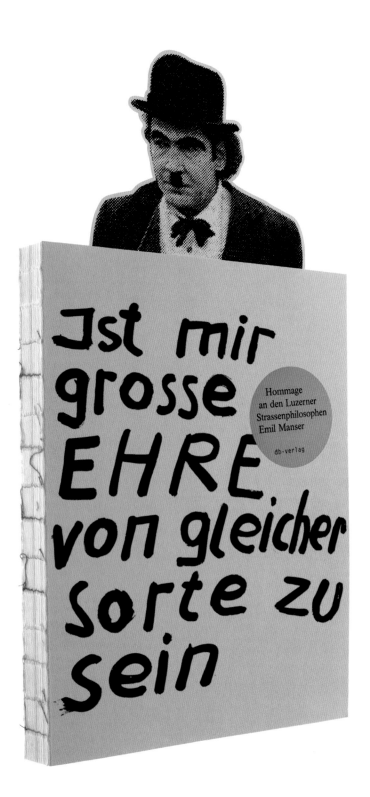

Ist mir grosse EHRE von gleicher sorte zu sein

Hommage an den Luzerner Strassenphilosophen Emil Manser

db-verlag

Mandarine

*Ist Mir Grosse Ehre von Gleicher Sorte zu Sein (Tribute to the Street Philosopher Emil Manser)*
Erich Brechbühl/Mixer
www.mixer.ch

The protagonist of this book is the philosopher Emil Manser. The cover and content of the book refer to Manser's style of painting posters. An orange circle on the cover underscores the tribute that the book pays to the philosopher.

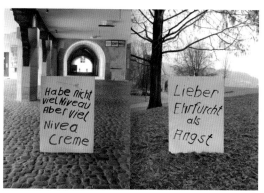
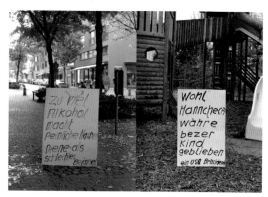
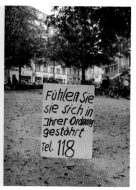

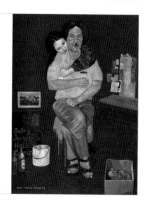

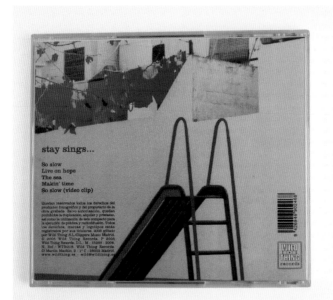
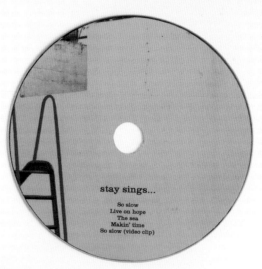

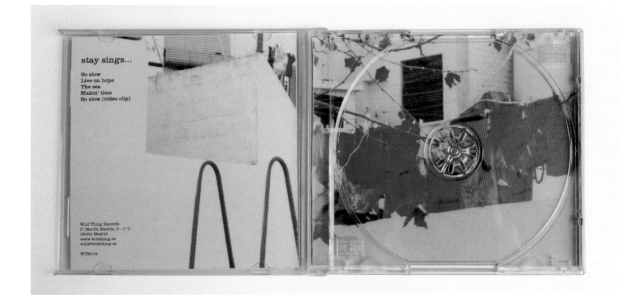

Saffron

Stay

Otto&Olaf

www.otto-olaf.com

Cover for the single of a Catalan
indie-pop group. The photography
was spontaneous. The elegance of
the contrast between the washing
hung according to the color of the
clothes and its correspondence
with the colors of the slide can be
appreciated.

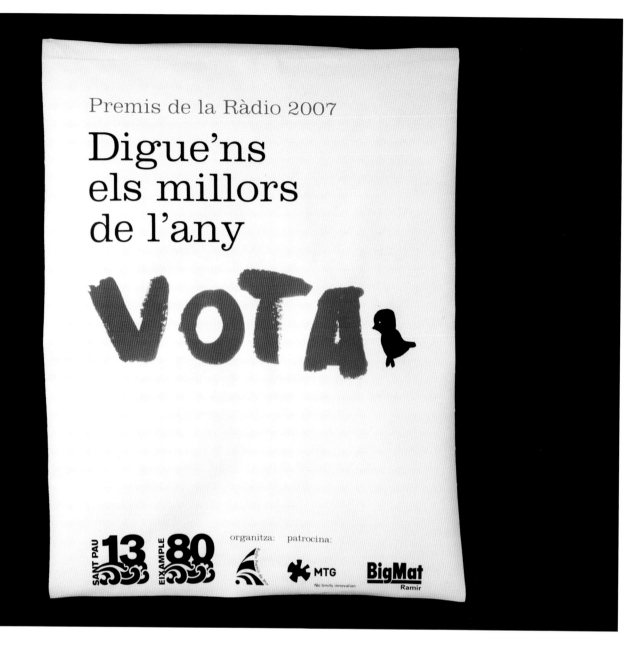

Vermillion

Ràdio Premià de Mar
Otto&Olaf
www.otto-olaf.com

Image for the 2007 edition of a local radio contest in Premià de Mar (Barcelona). Fluorescent vermillion was used to grab people's attention and encourage participation in the contest.

95,2 fm

www.premisdelaradio.org

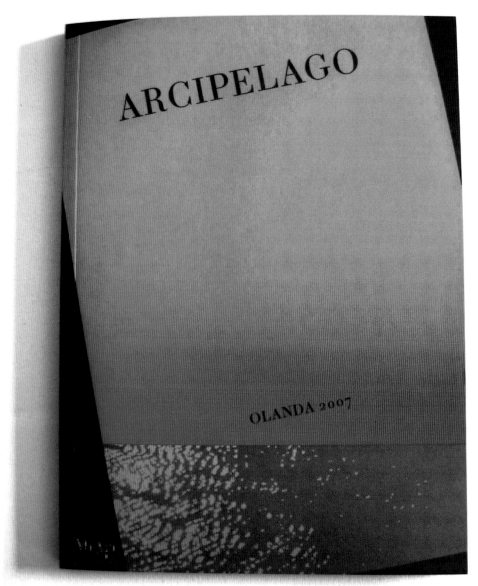

**Gold Sunshine**

Arcipelago

Karen van der Kraats

www.karenvandekraats.com

Catalog for the exhibition of the Milan art fair MiArt in March 2007. Along with navy blue, pink and orange—in reference to the Netherlands, guest country of the exhibition—a sophisticated gold predominates.

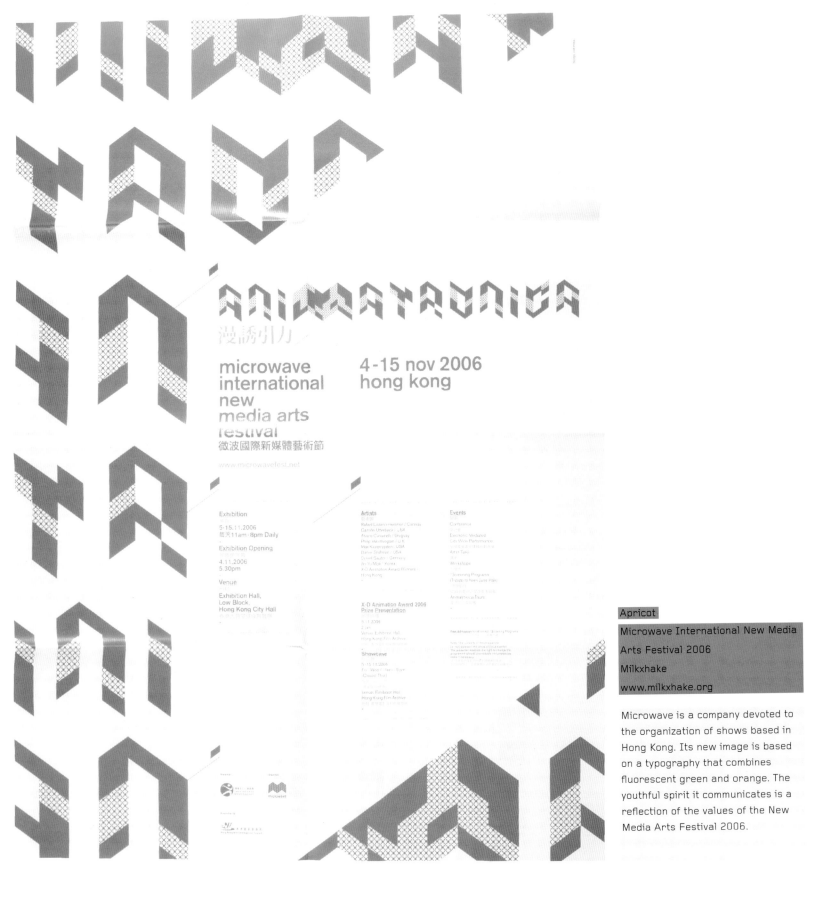

ANIMATRONICA
漫誘引力

microwave
international
new
media arts
festival
微波國際新媒體藝術節
www.microwavefest.net

4-15 nov 2006
hong kong

Exhibition

5-15.11.2006
每天11am-8pm Daily

Exhibition Opening

4.11.2006
5.30pm

Venue

Exhibition Hall,
Low Block,
Hong Kong City Hall

Artists

Rafael Lozano-Hemmer / Canada
Camille Utterback / USA
Alvaro Cassinelli / Uruguay
Philip Worthington / U.K.
Max Kazemzadeh / USA
Dennis Teichman / USA
David Gautier / Germany
Jin Yo Mok / Korea
X-D Animation Award Winners /
Hong Kong

X-D Animation Award 2006
Prize Presentation

Showcase

Events

Conference

Electronic Mediated
Live Work Performance

Artist Talk

Workshops

Screening Programs

Animatronica Tours

Apricot

Microwave International New Media
Arts Festival 2006
Milkxhake
www.milkxhake.org

Microwave is a company devoted to
the organization of shows based in
Hong Kong. Its new image is based
on a typography that combines
fluorescent green and orange. The
youthful spirit it communicates is a
reflection of the values of the New
Media Arts Festival 2006.

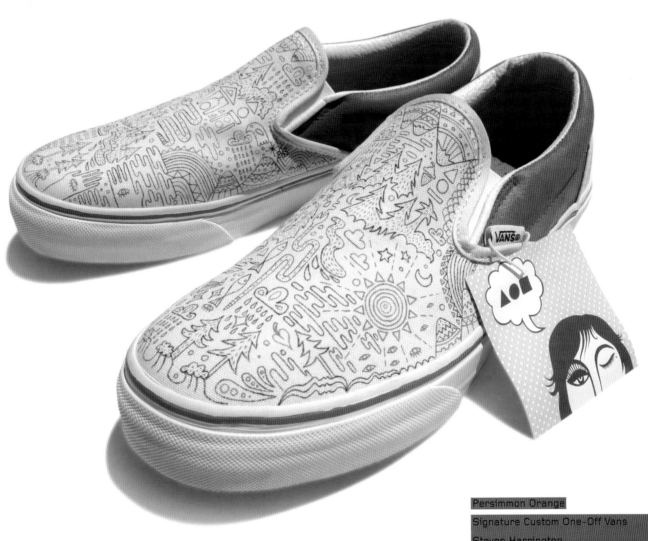

**Persimmon Orange**

Signature Custom One-Off Vans
Steven Harrington
www.stevenharrington.com

Vans collection created for
Customize Me. The sample design is
a mix of warm tones, with orange as
the color referent. The forms of the
drawings take inspiration in nature:
trees, leaves, waves, fish, clouds,
the sun . . .

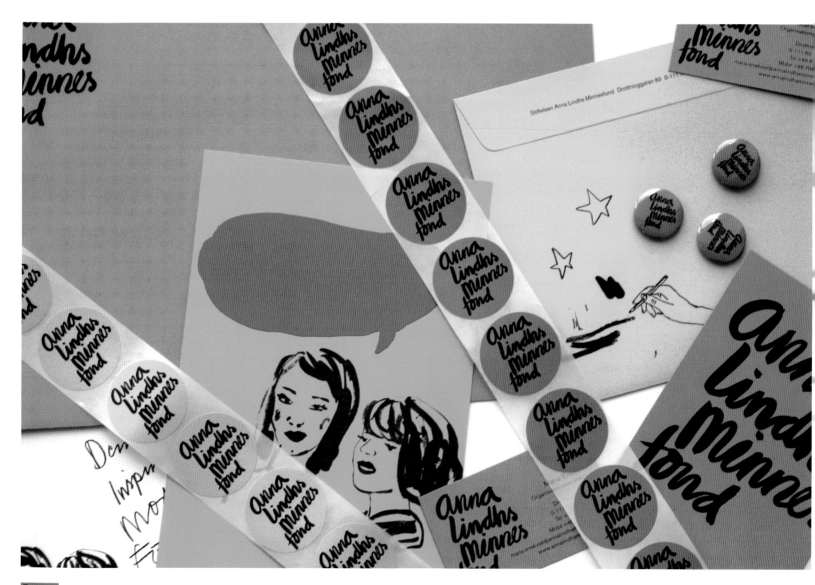

**Butane**

Anna Lindhs Minnes Fond

Erica Jacobson Design

www.ericajacobson.com

New graphic image for the fund in memory of politician Anna Lindhs. The strong, vivid colors (orange, light blue and green) and hand-drawn typography express courage and the valor required for making oneself heard in our society.

Harvest Pumpkin
Monda Lironda
Otto&Olaf
www.otto-olaf.com

Packaging and corporate image
of a company devoted to the sale of
citrus. The ecological character of
the company is reflected in its image:
an orange painted by a child.

# monda lironda
### right from the tree

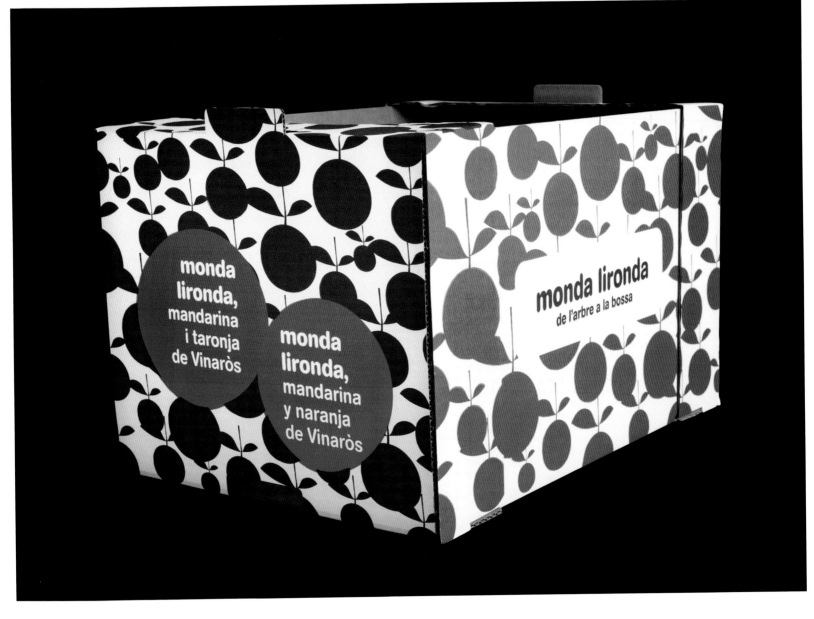

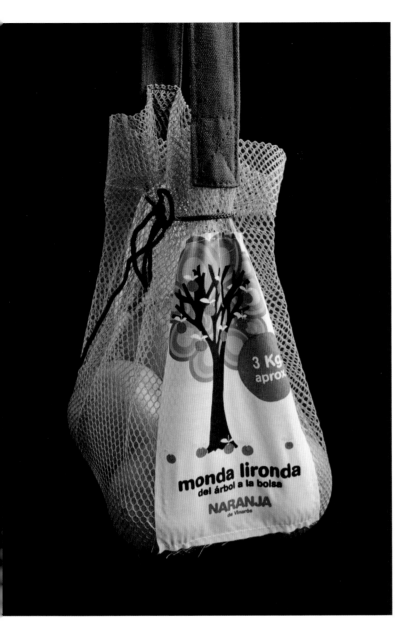

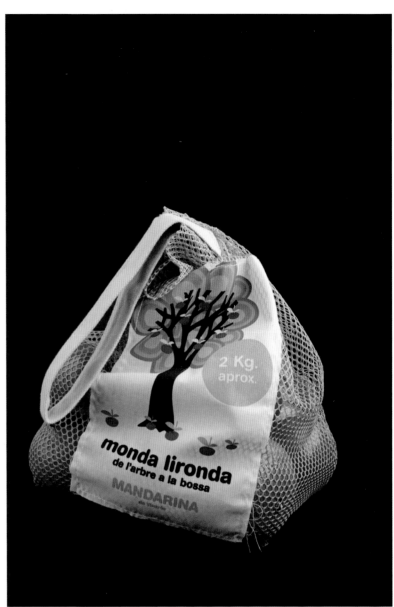

## Dry Leaves

**P45 (Numéro 11)**

Anouk Pennel, Raphaël Daudelin/Feed

www.studiofeed.ca

Cultural magazine of Montreal. In this fall issue, there was a move toward seasonal color change, orange and black, using fluorescent ink. The combination of these colors resulted in an arsenal of browns, also very typical of the season.

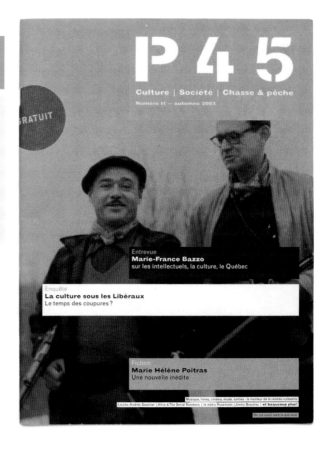

## La fin de Mignonne

Une partie de chasse joyeuse, débât sur, laquelle les rôles s'inversent pour, se fin, démontrer le coupable. Une nouvelle inédite de Marie-Hélène Poitras

*À Raymond et Alice Jean Alice Cinter*

C'était l'endroit parfait pour
se convaincre de la vacuité du
monde juste avant une overdose,
le genre d'espace où on fait
rouiller du métal jusqu'à ce
qu'il se métamorphose en une
poudre rousse pareille à de l'héroïne,
à du sucre de canne biologique.

From Simply Red
to Tango Passion

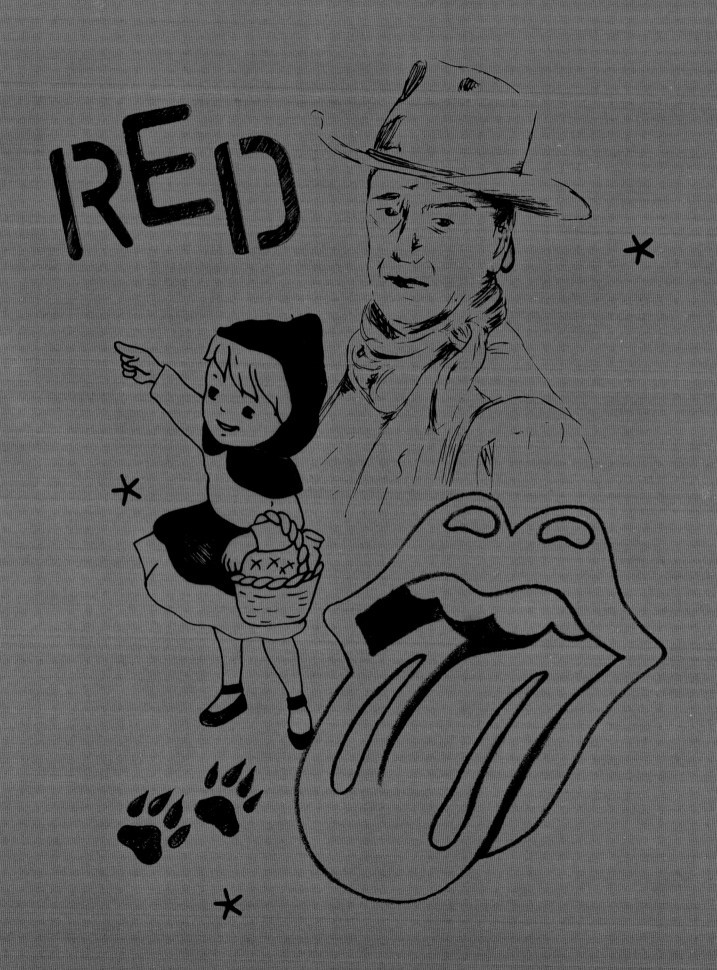

Color of colors. Equally hated and loved, it does not owe its popularity to its good nature but to its shameless, ambitious, and unyielding charisma. If it can't be the star, it prefers to remain out of the spotlight, although, if it wanted to, no color could overshadow it.

There is no memory without it. It is blood and it is fire. It is life itself. Irreverent and deceitful, it has the cynical sense of humor of mercenaries. It is irresistible.

Its gaze conceals the vertigo of the unknown, and any color that approaches it abandons its will.

Politics do not impress it. Nor does the blood shed in wars or religious ceremony. It is beyond all doctrine. But if one is lucky enough to encounter it one night seated at a bar, dazed by too much wine, its gaze watery, speech slurred, perhaps they will be privileged enough to hear its story:

"I've always felt like the lost sheep that nonetheless is lucky in life. I have everything, but am never alone and something is always expected of me. Good or bad, it's not important. They wait for a gesture, an inappropriate remark, a fresh argument . . . Anything. If they were told what makes me happy, they wouldn't believe it, and yet . . . remember Little Red Riding Hood? Well then: when I need a little peace in the midst of my turbulent life, I recall the little girl crossing the dense, diabolical forest unaware of the wolf lying in wait, humming songs to herself in a soft voice, sheltered by her red hood, while rocking the basket that holds food for her grandmother. It is an image that comforts me, and I am proud that this story bears my mark."

It likes to read books of history, the Rolling Stones, and any classic Western in black and white.

Its most famous statement: "Out of my way."

Simply Red

Red Skin

Tomato

Red Wine

Sparkling Love

Lipstick Red

Aurora Red

Swiss Red

Geranium

Rococo Red

Tango Passion

Simply Red

*Cultura Porquería*

David Torrents

www.torrents.info

Project that plays with graphic stereotypes and is oddly beautiful due to its apparent ugliness. An imaginative world that the author has been compiling over the course of his career in which basic red stands out as the primary color.

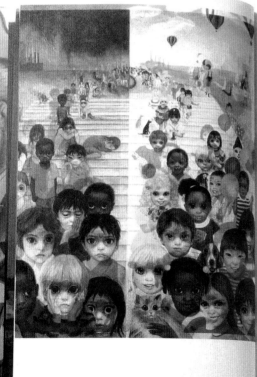

Doncs si és una porqueria, per què l'ensenyen? Aquesta pregunta segur que la faran moltes persones davant l'anunci d'una exposició amb el títol de "Cultura porqueria". Les definicions de cultura són infinites i, pels que utilitzin una accepció molt restrictiva, que la redueixi a l'excel·lència i la virtut creativa, probablement no hi haurà resposta satisfactòria. Però la cultura també són –independentment de la seva qualitat– les fites i els motius que marquen el paisatge familiar de tots plegats. I en aquest paisatge apareixen sovint signes i manifestacions –pintura, espectacles, música, imatge– que partint de l'error, de la deixadesa –és a dir, de l'antiexcel·lència voluntària– s'acaben convertint, per uns mecanismes socials que l'exposició intenta explicar o posar de manifest, en elements de significació cultural. La cultura porqueria seria, en bona part, una cultura a contracor, una avantguarda que mai no va voler ser-ho. Però que tanmateix pobla molts espais de la nostra vida quotidiana, sense que forçosament reparem sempre en la seva presència. Mirada des d'avui, es podria pensar que la cultura porqueria és una forma que pren la cultura popular en sortir de la modernitat, en entrar en una fase postheroica i postidentitària de l'aventura humana. Però en realitat el joc característic de la cultura porqueria, la fascinació per l'error, per la monstruositat, per la lletjor, pel descuit, per una incompetència que sembla molt treballada, és fruit d'un mecanisme d'exaltació de l'espectador –que rep la recompensa de sentir-se més

dotat, més normal, més guapo, més polit, més eficient que l'artista– que ve de lluny. La novetat és que el que havia circulat sempre als marges de la modernitat, guanya centralitat –després de mutar en formes noves adequades a una cultura molt més audiovisual– en aquests temps de sortida de la modernitat. I afegeix confusió sobre la direcció del camí que hem emprès, si és que n'hi ha alguna.

L'error com a estratègia cultural seria l'argument. Una forma reeixida de crear productes culturals d'incidència imprevisible. Quan es parla de cultura porqueria tothom mira cap a la "tele". És cert que aquesta ha estat una via eficaç per vehicular aquests productes que es basen en la normalització d'allò abjecte, en la humiliació dels personatges i en l'exhibició de monstruositats. *Crónicas marcianas* és un exemple de cultura porqueria tan perfecte que està al límit, a punt de deixar de ser considerat com a tal. Però hi ha molts altres camps en què la monstruositat –les atraccions de fira, per exemple–, l'abjecció –els dibuixos i pintures de *serial killers*– o la humiliació –el ridícul– adquireixen carta de naturalesa cultural. I en cert sentit fan una funció subversiva com si, per un procediment de sedimentació de l'error i del sinistre, posessin el propi sistema en evidència. És en aquest sentit que la cultura porqueria pot esdevenir avantguarda ocasional.

Aquest doble joc d'alienació de l'espectador en la porqueria i de finestra a les misèries del social és el que intenta resseguir aquesta exposició. Una certa espeleologia del gust: és a dir, un descens a les cavernes de la cultura postcontemporània.

Josep Ramoneda
Director del CCCB

Índex

# DESCOBRIR L'ACORD PERDUT

Irwin Chusid

## Elogi de la música *outsider*

La música *outsider* és un tipus de música que les persones amb gustos corrents considerarien "dolenta", "inepta" o potser lamentablement "ingènua". És creada per gent amb intencions sinceres i que generalment no és conscient de la gran distància que separa els seus esforços dels estàndards convencionals.

La música *outsider* és l'equivalent sònic de les més conegudes arts visuals *outsider*: pintura, escultura, muntatge i mescla de mitjans. Si bé l'expressió *art outsider* es va implantar en la dècada dels setanta, després de la publicació d'un llibre de Roger Cardinal amb el mateix títol, té una tradició que es remunta com a mínim als estudis de creacions de malalts mentals psicòtics durant el segle xix. Durant els anys vint va ser reivindicada pels francesos, que més tard el van anomenar *art brut*. Entre altres etiquetes, trobem les *d'art intuïtiu*, *folk*, *visionari* o *autodidacte*; *fabuloserie*, *amateur vérité* i *art naïf*. Van aparèixer creadors icònics en la pintura (Bill Traylor, Henry Darger i Howard Finster, que també van enregistrar cançons), el cinema (Ed Wood Jr. i Klaus Beyer, que també canta i enregistra homenatges als Beatles), la literatura (Darger, Adolf Wölfli, que també componia), el paisatgisme

(la *Muntanya de la Salvació* de Leonard Knight), l'escultura (William Edmondson, el *Jardí de l'Edén* de S.P. Dinsmoor) i l'arquitectura (Edward Leedskalnin, Simon Rodia). Per definició, entre aquests visionaris n'hi ha moltíssims que potser ni tan sols sentirem mai anomenar.

No obstant això, per la raó que fos, l'adjectiu *outsider* no s'havia aplicat a la música. L'interès per la forma –però no pas el títol honorífic–, va començar a aparèixer a l'última dècada del segle xx gràcies a llibres com *Incredibly Strange Music* i a una profusió d'edicions de CD d'artistes que fins llavors no es coneixien, com B.J. Snowden, Wesley Willis, Lucia Pamela i Eilert Pilarm. Ara ja sembla evident que aquests intèrprets "especials" tenen un parentiu musical amb Rizzoli i Sister Gertrude, però la seva obra no havia estat mai elogiada en uns termes tan categòrics. (Per confirmar el parentiu, uns quants músics *outsider* també s'han dedicat –i en alguns casos han arribat a ser famosos– a les arts visuals; entre ells hi ha Daniel Johnston, Wesley Willis, Harry Partch i Lucia Pamela).

La majoria de la gent sembla tenir molt clar quina música és "bona" quan la sent. La música que té

èxit en el mercat en general –l'anomenada "popular"– compleix els estàndards de melodia, harmonia i tonalitat. El ritme és del tot consistent i la lletra tendeix a referir-se, profundament o insulsament, a la nostra cultura i experiència compartides. De tant en tant, la música popular és prou intel·ligent per plantejar un repte o per sonar lliure de convencions, però, en la majoria de casos, les fórmules bàsiques es mantenen intactes. Hi ha el que és "bo" i el que és "dolent", i els productors, directors de cases discogràfiques i programadors d'emissores de ràdio reben sumes obscenes per decidir el que convé (o no convé) al mercat. En uns temps de multigravacions en multipistes i unions digitals, es pot arreglar qualsevol interpretació dolenta. I, si bé els productors saben treballar amb errors serendípitics, la majoria de professionals dels estudis prefereixen tornar a enregistrar una nota equivocada o un acord desafinat fins que surti bé. Imaginem, però, un univers musical en què no existeixin aquests estàndards, en què les notes més enllà del sol s'explorin amb ímpetu. Vaig escriure el llibre *Songs in the Key of Z* com un mapa pangalàctic de música estrafolària i visionària en què tots els camins porten

invariablement a un sol lloc: el precipici. Com el dibuix d'una subclasse musical vista a través de l'objectiu de Diane Arbus.

Estilísticament, els *outsider* cobreixen tot l'espectre –des dels desinhibits udols de coiot del Legendary Stardust Cowboy fins a la passió de l'etern adolescent Daniel Johnston; des de la sensibleria que es mira el melic del *Third Eye* d'Arcesia al rock aborigen i remot de les Shaggs; des de la bogeria lunar de Lucia Pamela, fins a les 35.000 (així ho afirma ell) cançons *techno-rock* de Wesley Willis, la majoria de les quals sonen igual. Com qualsevol altra manifestació artística estrafolària, la música *outsider* sorgeix de maneres misterioses. Podria ser el producte d'un ADN defectuós, d'atacs psicòtics o de l'abducció d'extraterrestres. Potser una negligència mèdica, l'empresonament o simplement un excés de drogues en desencadenen l'evolució. O la possessió demoníaca, o la submissió a Jesús. Atribuïm-ho al creixement en comunes o a la cervesa de mala qualitat. És possible que alguns músics es mediquin i tinguin impulsos volàtils (Daniel Johnston, el Legendary Stardust Cowboy, Joe Meek), altres són joganers i "agradablement bojos" (Lucia Pamela, Jan Terri, la

sempre). I en el terreny ideològic, entre el simulacre, el succedani, el garrulisme, el *quiero y no puedo...* i això puedo en tot. Les nostres vides flueixen, sense cap possibilitat d'aturar-se, en un incessant i absurd compleix d'idees, éssers i coses que perden el seu sentit al cap de cinc minuts (el ninot Curro 92, Hormaechea, la Veneno...) i de conceptes pomposos que mai no tenen entes però que han estat buidats de tot significat (democràcia, justícia, solidaritat, igualtat...), i tot plegat corrent pels marges tragicòmics de la imitació de clixés i explotació de les modes (perdó, tendències), i la improvisació nacional sobre la qual es basa el nostre tradicional *statu quo* del "tente, mientras cobro". Les nostres "semivides" és trist dir-ho, però més trist és experimentar-ho –no s'enquadren en un marc històric postindustrial *comme il le faut*, sinó en la vella fira, ara completament desarrelada, dels quincallers i derivats. La nostra "quasi-vida" (cultural, política, social, ideològica...), insistim, és pura brossa. A la fi s'ha fet realitat el somni de la nostra vella classe dirigent de tota la vida. Espanya-porqueria és una primera potència, però de debò. Ja ho advertien els nostres savis: "Ser espanyol és una de les poques coses serioses que es poden ser en aquest món."

En l'àmbit domèstic, si Espanya fos un programa de televisió, seria el *Gran Hermano*. En el social, seria el més semblant a un succés colorista que se salda amb unes "lesions incompatibles amb la vida". I en el pla cultural, molt senzill: les glòries esportives del Real Madrid que campegen per Europa. És a dir, allò més semblant a l'Espanya de què van gaudir l'Equipo A, McGyver i James Bond, per aquest ordre. Un tot de conceptes, conductes i productes grollers, de quincalla del segle xx, realitzat i dirigit per un país que encapçala el Tercer Món, el centre de l'eix Madrid-Marbella-l'Aràbia Saudita. I, encara pitjor, molt més ràpida, molt més gran i molt més desvariejada fins i tot que la cultura porqueria nord-americana de saló. Un succedani grandiós del subproducte oficial.

En casa de la Condesa Gunilla Von Bismarck
WHITE HORSE ...of course

El Bombo de España

## *Hippotragus leucophaeus*
## Bluebuck

**1799**

## *Raphus cucullatus*
## Dodo

**1681**

## *Changchengornis*
## —

**120 million years ago**

Red Skin

*Heed My Warnings 2*
Theo Wang, Tom Boulton/Sort
Design (Society of Revisionist
Typographers)
www.sortdesign.com

*Heed My Warnings 2*, a limited edition
work, denounces the extinction of
animal species. All the illustrations
were done by hand and are
distinguishable from the text thanks
to the use of two colors. Red alerts
us to the disappearance of species.

# HEED
*MY*
# WARNINGS
2

# OUR LOST
# BESTIARY

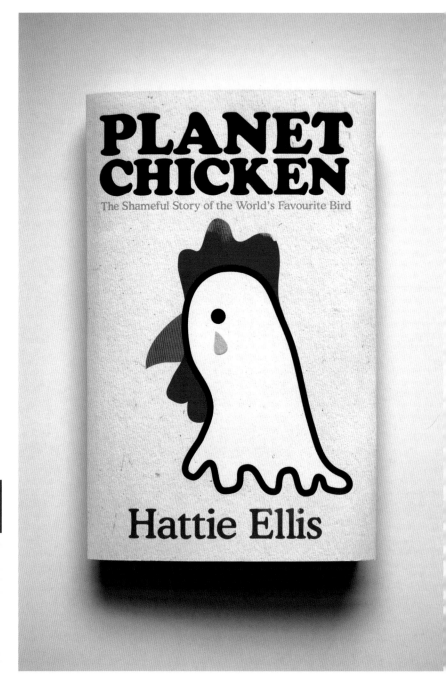

**Tomato**

*Planet Chicken*
Marcus Walters
www.marcuswalters.com

Dust jacket of a book that denounces the cruelty of the poultry industry and the mistreatment of poultry. The colors of the illustration are those of the depicted bird, except for the tear, a metaphor and summary of the subject matter of the book.

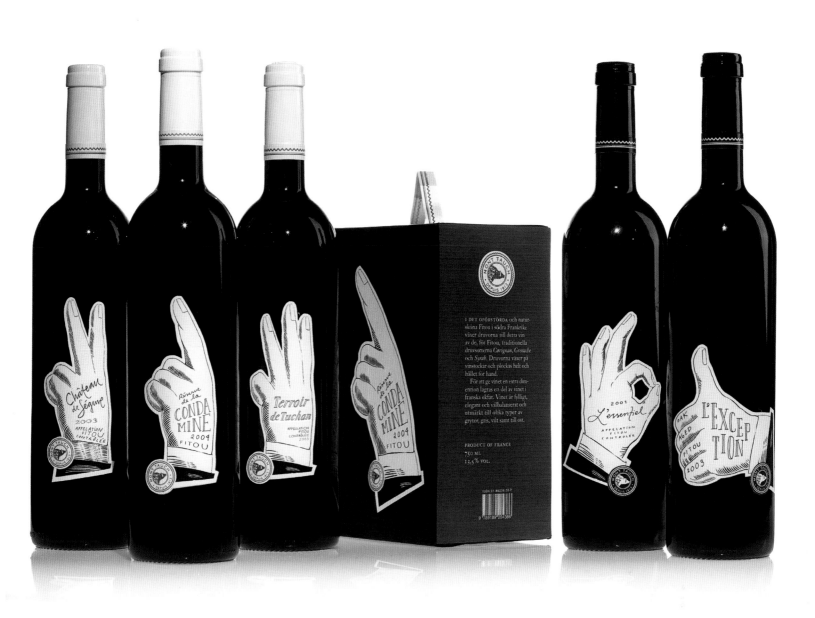

Red Wine

A Wine Collection for Mont Tauch

Hanne Backman/Lula

www.lula.se

Final project of HDK, Design School of the University of Gothenburg. The work, created in 2006, consisted of coming up with an idea for the wines of a French cooperative. The numbering or gestures of the fingers indicate the quality of the wine.

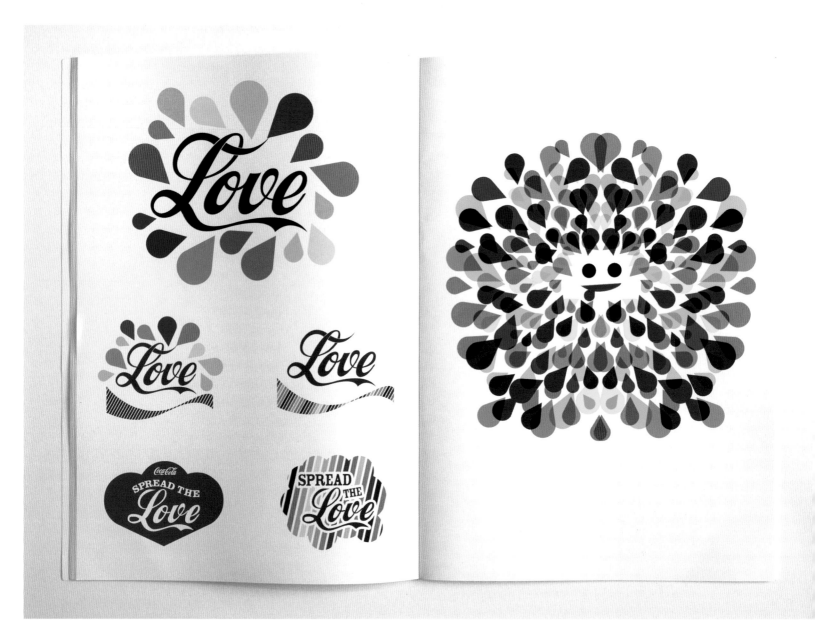

Sparkling Love

Coke (Creative Concepts, Mother London)

Marcus Walters

www.marcuswalters.com

Project with a purpose: finding new ways to represent the image of Coca-Cola. Elements, colors and forms that reinvent the logo and bottle, without sacrificing the classic Coca-Cola red.

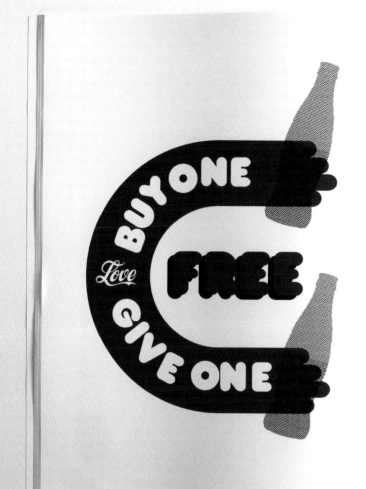

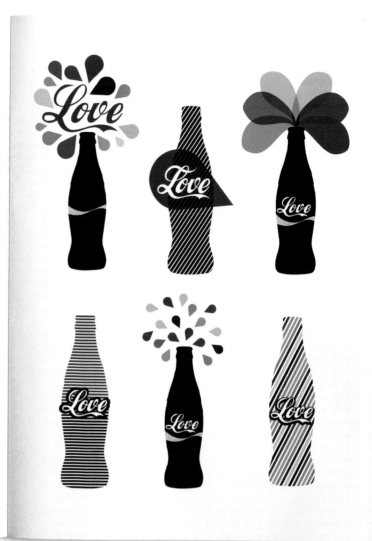

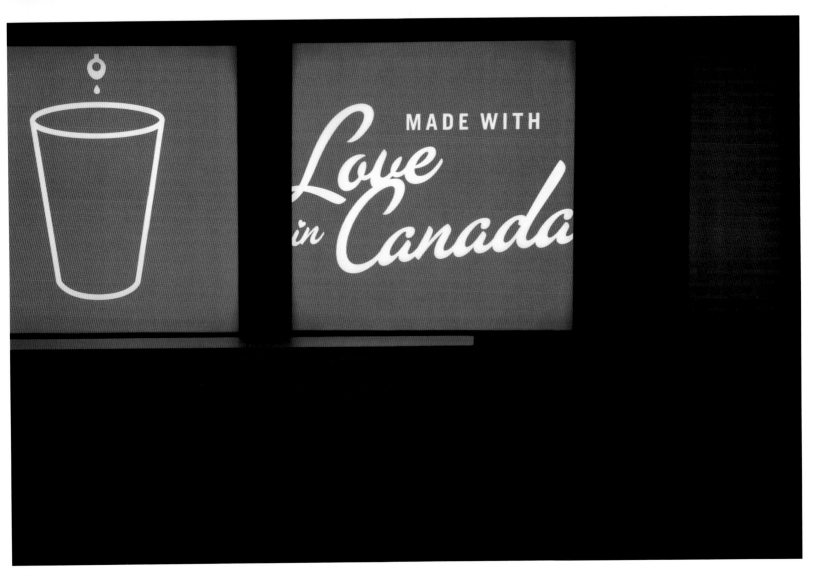

The red and white of the Canadian
flag bear witness to the idea of
a genuine Canadian product, one
of the distinctive features of this
company. The illustrations are basic
icons of Canadian life.

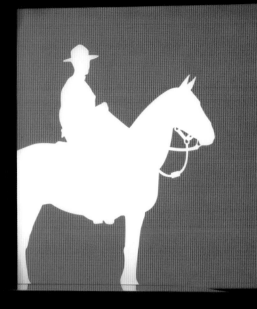
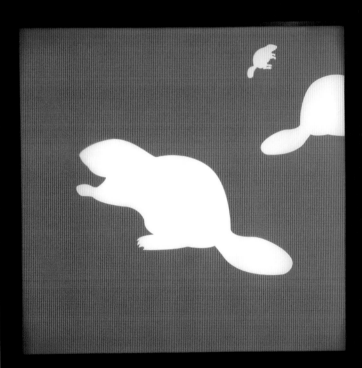

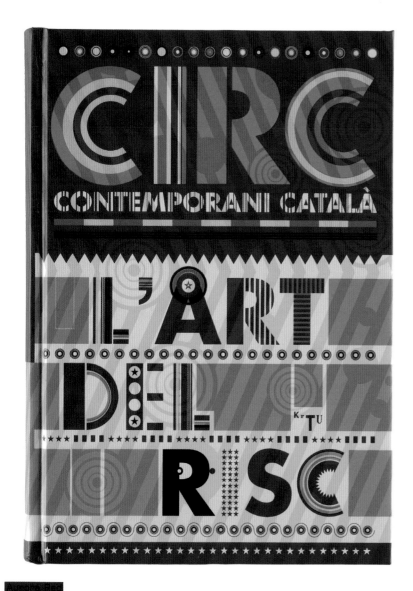

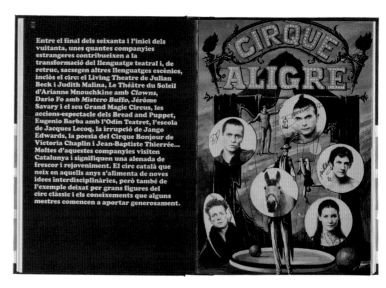

Entre el final dels seixanta i l'inici dels vuitanta, unes quantes companyies estrangeres contribueixen a la transformació del llenguatge teatral i, de retruc, sacsegen altres llenguatges escènics, inclòs el circ: el Living Theatre de Julian Beck i Judith Malina, Le Théâtre du Soleil d'Arianne Mnouchkine amb *Clowns*, Dario Fo amb *Mistero Buffo*, Jérôme Savary i el seu Grand Magic Circus, les accions-espectacle dels Bread and Puppet, Eugenio Barba amb l'Odin Teatret, l'escola de Jacques Lecoq, la irrupció de Jango Edwards, la poesia del Cirque Bonjour de Victoria Chaplin i Jean-Baptiste Thierrée... Moltes d'aquestes companyies visiten Catalunya i signifiquen una alenada de frescor i rejoveniment. El circ català que neix en aquells anys s'alimenta de noves idees interdisciplinàries, però també de l'exemple deixat per grans figures del circ clàssic i els coneixements que alguns mestres comencen a aportar generosament.

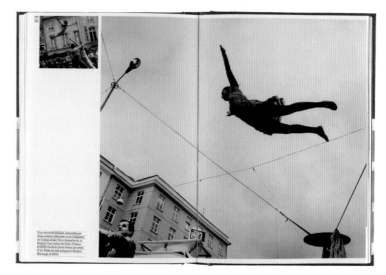

Like circus tents, the chromatic foundation of this book is red and white. In addition, it borrows geometric forms and typographies based on elements of traditional and contemporary circuses.

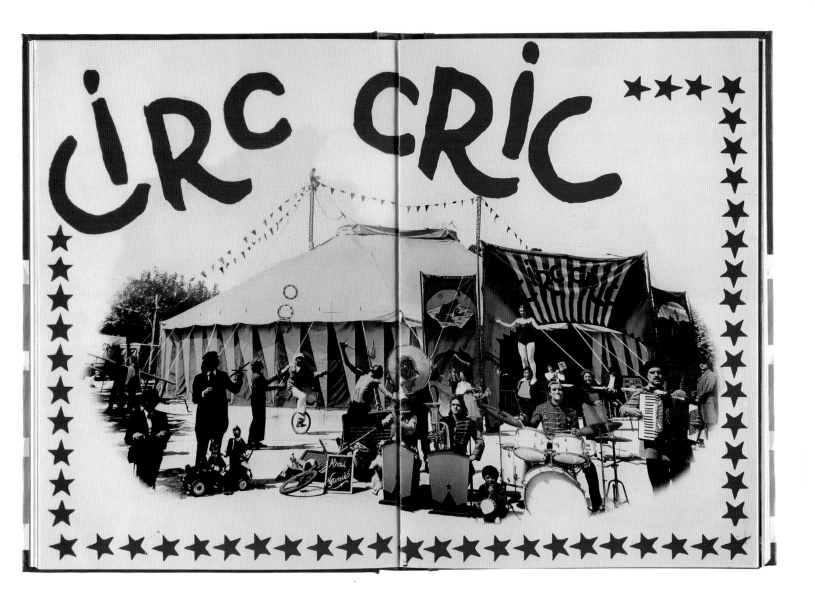

**OPEN NOW.**

AM GENDARMENMARKT
FRANZÖSISCHE STRASSE 40
10117 BERLIN GERMANY
WWW.THECORNERBERLIN.DE

THE CORNER BERLIN

Swiss Red

The Corner Berlin
Christiane Bördner/Jesse Becker/
E-design + communication
www.agentur-e.com

New marketing department for
exclusive fashion brands. The
mailing and poster are based on
its corporate image. It was used to
introduce a new collection, playing
abundantly with space, a reduced
design, and red as the sole color.

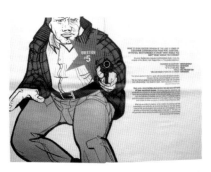

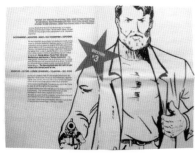

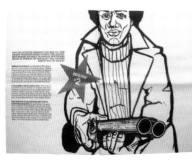

Shoot!
Gregori Saavedra
www.gregorisaavedra.com

Universal Studios wants to respond to direct questions clearly. The chromatic combination of the white background, the drawings outlined in black, and the red stars that simulate the impact of bullets suggest drama, seriousness and strength.

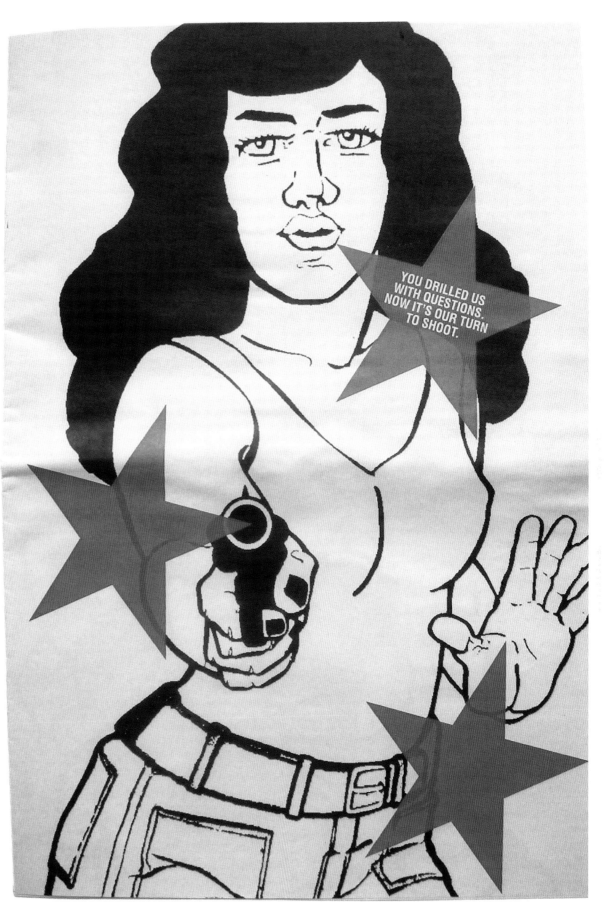

YOU DRILLED US WITH QUESTIONS. NOW IT'S OUR TURN TO SHOOT.

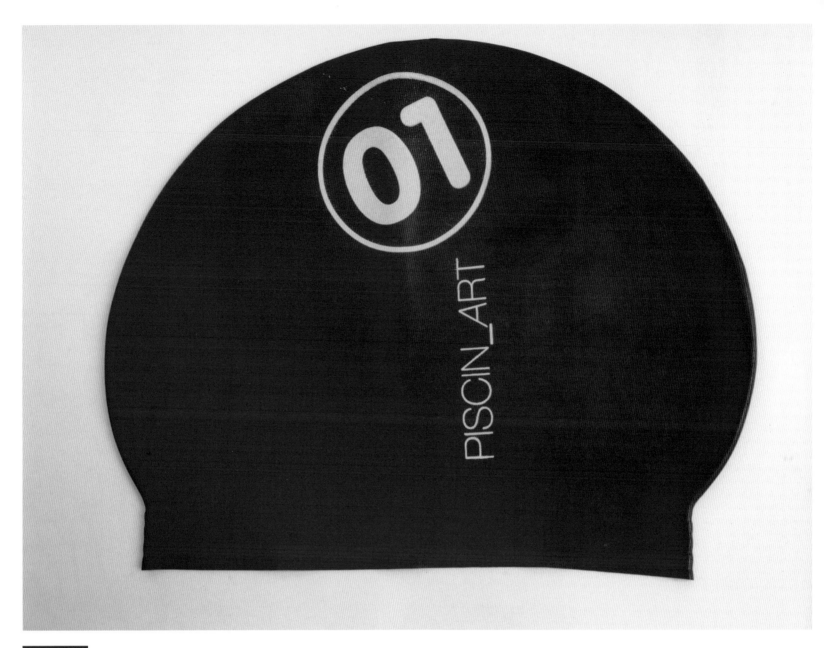

Rococo Red

Piscin_Art
Otto&Olaf
www.otto-olaf.com

Image for an art exhibition held on
the premises of several municipal
pools in 2006. Combination of
white, blue and red. Red is the color
selected for the swimming caps,
complimentary gifts for visitors.

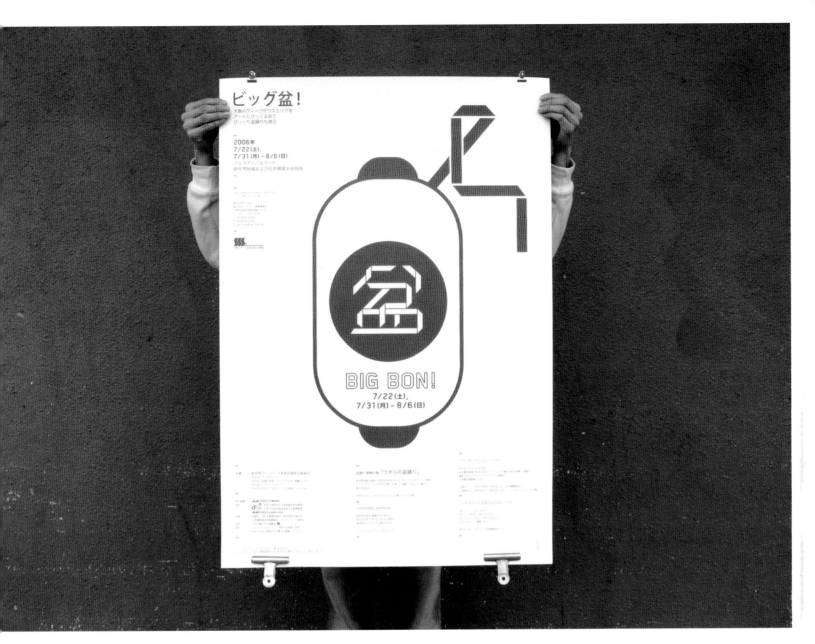

Osaka Design Pack Big Bon!

Milkxhake

www.milkxhake.org

The poster uses red against a white background, in allusion to the Japanese flag. The theme of the poster—traditional Japanese dances—contrasts with the contemporary character of the design.

**From Peony
to Pink Panther**

One cannot say anything disparaging about it, other than that it squanders its life dreaming, not on hallucinatory and confusing nocturnal dreams but on daydreams, those that are like a secret and unstoppable passion. About it one might say: it does not live its life, but dreams of the life it would like to live.

It is the smallest of the colors, and more often than not, must put up with the taunts of some and the condescension of others. And yet it maintains its composure, despite abhorring its position in the chromatic family. Being the little brother is never easy.

Like all dreamers, it goes through periods of euphoria and others of melancholy. Sometime it feels special, other times common. Just like grand old figures of the past, not a day goes by when it doesn't recall its golden age, when rococo ruled the world of fashion and declared: "Fashion is Pink." It was a time when Madame Pompadour set trends like an eighteenth-century Coco Chanel. Pink was the color of distinction and good tastes in clothes, in makeup, in furniture. . . . It was the color of luxury. But those days are over.

Still, it does not fret at its rebirth in the world of children. In fact, it likes to think of it as a kind of rococo in miniature. Even if it involves games, it has always preferred the warm erotic naked games of adults, which it colors better than anyone.

It believes in miracles and has a sweet tooth.

Presently New York is its town. It adores the films of Sofia Coppola and the music of Rufus Wainwright.

Its most famous statement: "Reality bores me."

Peony

Rose Shadow

Marie Antoinette

Begonia Pink

Cactus Flower

Pink Flamingo

Rose Petals

Marshmallow

Smoked Pink

Pink Panties

Strawberry Milkshake

Pink Panther

THE
CLOCK
ON
THE
MANTEL
IS

BROKEN.

DOCTOR

IT

IS

T    I    M    E

Peony

Doctor Who vs Type
Thorbjørn Ankerstjerne
www.ankerstjerne.co.uk

This work belongs to a series of
posters designed for special effects
and the use of electronic music
in the series Doctor Who. It takes
chromatic inspiration in different
locations and the image of the
series.

Rose Shadow

Minichiello in PostScript!
James Fletcher/BytesReceived
www.bytesreceived.co.uk

PostScript is a page description
language used by numerous printers
and as a format for transporting
graphic archives in professional
print shops. The pink of the
intermediary pages separates
the content of the book.

Through the use of an everyday
object—hair clips, in this case—the
feminine character of this exhibition
which consists entirely of women is
revealed. The typography was created
in collaboration with Bobby Pins.

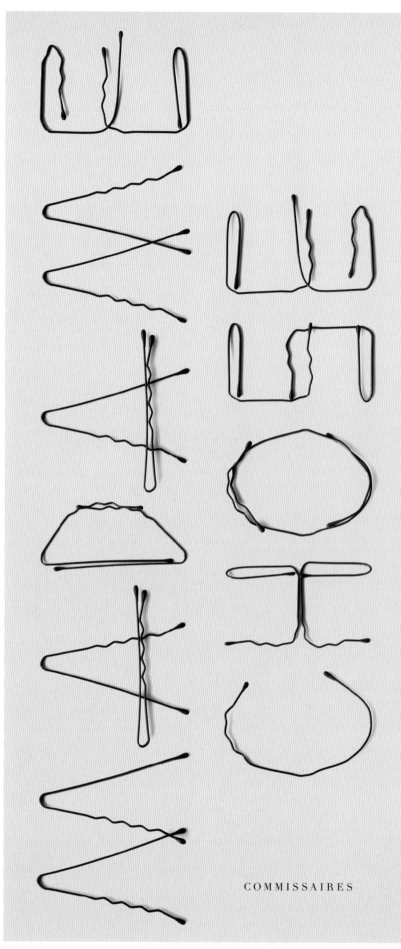

Les choses que font
Madame Bless,
Madame Johnson,
Madame van Eijk,
Madame Blain,
Madame Tsé-Tsé,
Madame Stickley,
Madame Goneau,
Madame Pap,
Madame MT,
Madame Jongerius,
Madame Cihat et
Madame Brugnoni
de Pandora.

Vernissage Madame Chose
et premier anniversaire
de Commissaires,
le jeudi 5 octobre à 18 h.
Madame Chose,
jusqu'à la fin de novembre.
5226, rue Saint-Laurent
514-274-4888

COMMISSAIRES

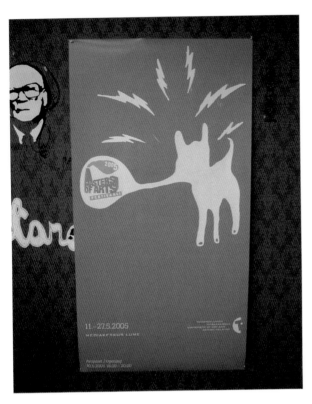

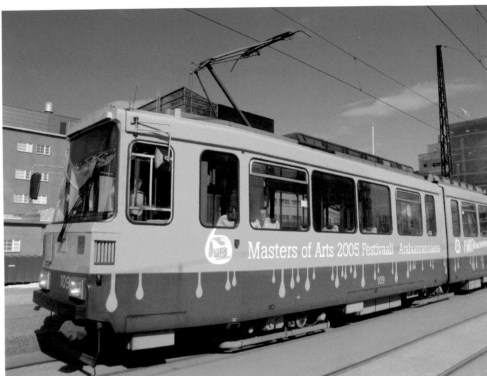

Begonia Pink

Masters of Arts Festivaali 2005
Anne-Mari Ahonen, Arja Karhumaa,
Daniel Bembibre
www.danielbembibre.com,
www.amadesign.com

Pink represents the arrival of the
sun and springtime in Helsinki,
the site of the 2005 Masters of
Arts Festivaali. All the promotional
elements of the festival were painted
in pink, from the posters to the
streetcars.

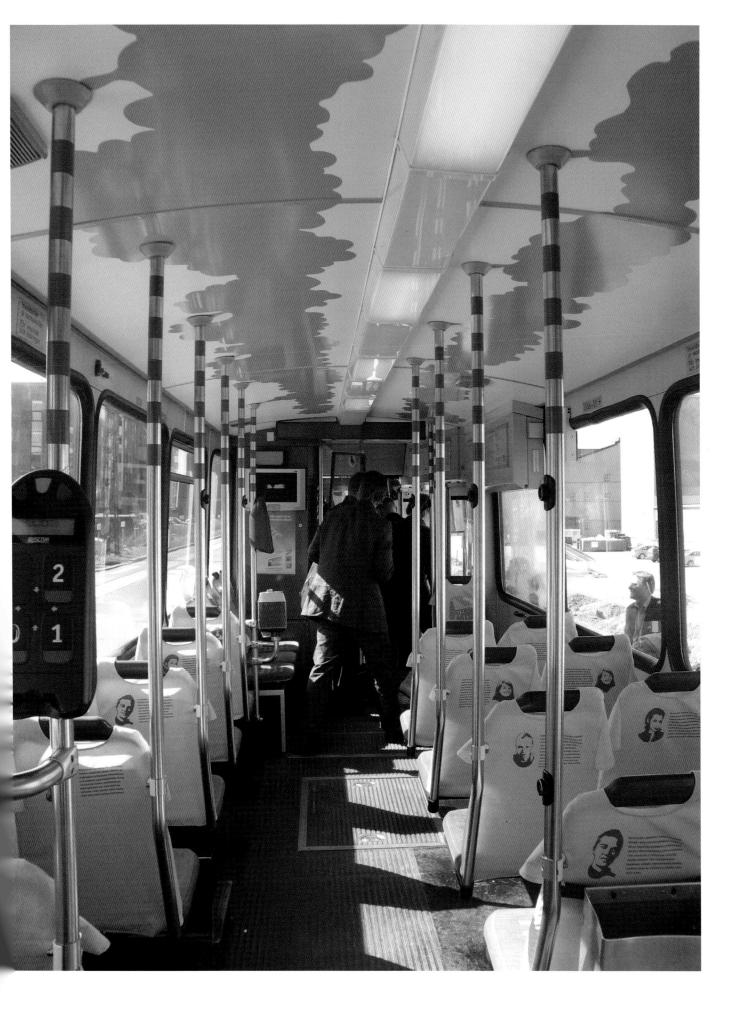

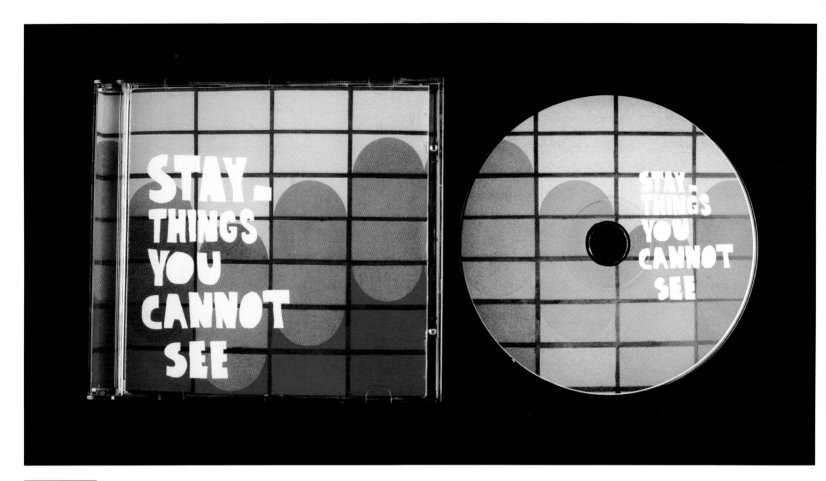

Cactus Flower

Stay
Otto&Olaf
www.otto-olaf.com

Cover and liner notes of the CD
of a Catalan indie-pop group.
Pyschedelic-like colors reveal the
style of the music. The white letters
stand out, giving the design a naive
touch.

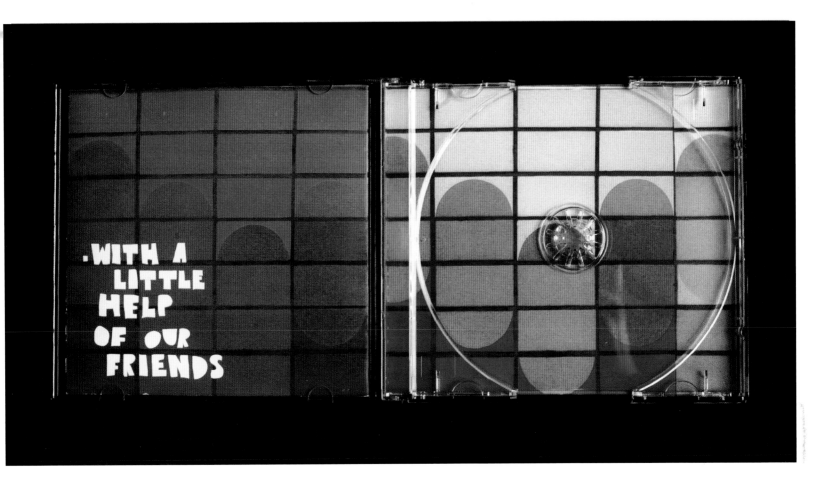

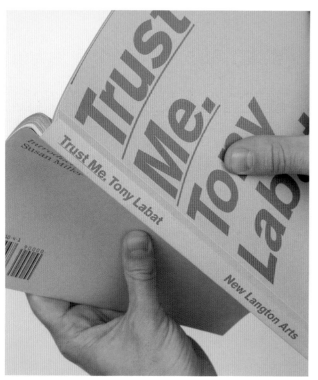

Pink Flamingo

*Trust Me*

Joshua Distler, Mike Abbink

www.joshuadistler.com

Monographic publication of the
artist Tony Labat. Pink is used for
the inserts and fluorescent red
for the cover and sleeves. Both
colors were chosen for their
vibrancy and legibility.

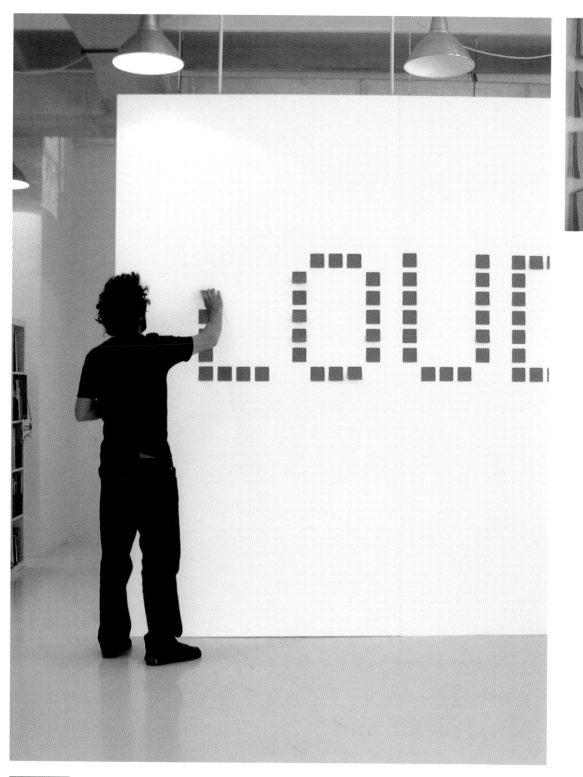

Rose Petals

Loud
Base Design, Borja Martínez
www.losiento.net

Sign for the offices of Loud
Barcelona, an event planning
company. The sign consists of blocks
of *post-its* in three shades of pink.
The daily use of the *post-its* results
in the constant change of color of
the sign.

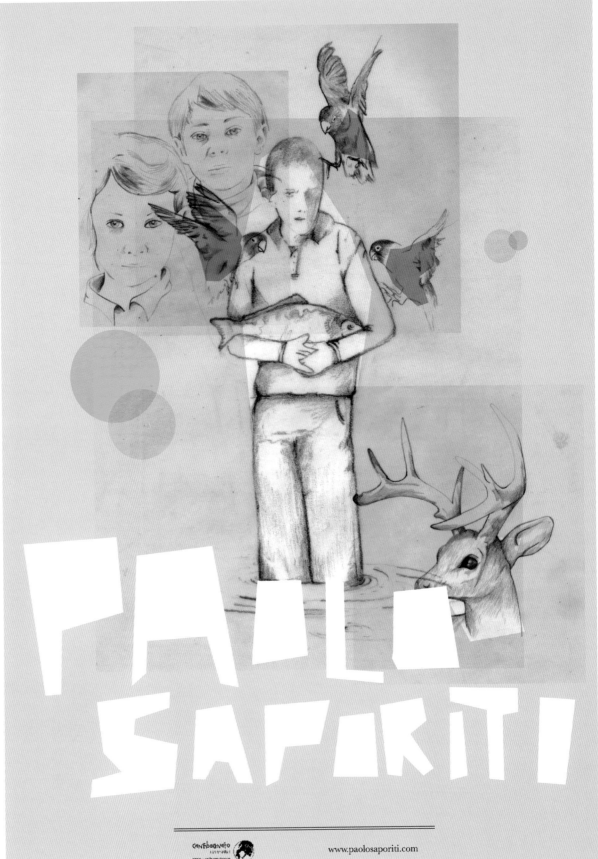

**Marshmallow**

Paolo Saporiti

Alessandro Maffioletti/Alvvino

www.alvvino.org

Poster for a series of concerts by an Italian rock singer. Pastel colors and a hazy atmosphere, with a pale pink background and figures drawn in pencil. As a counterpoint, the green and yellow plumage of birds.

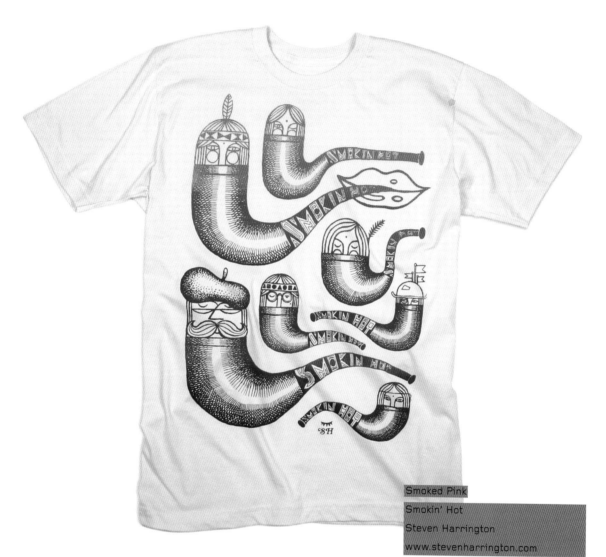

Smoked Pink

Smokin' Hot

Steven Harrington

www.stevenharrington.com

T-shirt designed for Threadless
Select, the fashion collection of an
on-line artist, with the culture of
pipe smoking as a motif. A chromatic
evolution from pink to blue crosses
the drawings on the shirt.

VERNISSAGE: SAMEDI 12 MAI
DE 17H00 A 19H00 AU CAN

ARTISTES: DARREN ALMOND, KADER ATTIA,
MASSIMILIANO BALDASSARRI, FRANCIS
BAUDEVIN, DONATELLA BERNARDI, TOBIAS
BERNSTRUP LILIAN BOURGEAT, DANIELE
BULETTI, COLLECTIF FACT, CHRIS CUNNINGHAM,
PHILIPPE DE CRAUZAT, WIM DELVOYE, LIONEL
FERCHAUD, FRED FISCHER, MASSIMO FURLAN,
PIERRE GATTONI, FABRIZIO GIANNINI, FABIEN
GIRAUD, LORI HERSBERGER, FRANÇOIS JAQUES,
VINCENT LAMOUROUX, ANNIKA LARSSON,
MATHIEU MERCIER, GEROLD MILLER, ELENA
MONTESINOS, SEBASTIAN MUNIZ, KARIM
NOURELDIN, X AVIER PERRENOUD, MATTHIEU
PILLOUD, HENRIK PLENGE JAKOBSEN, TILL
RABUS, JOËL VACHERON, PATRICK WEIDMANN,
MARTIN WIDMER, FRANCISCO DE MATA

# 13 MAI 07 –
# 30 JUIN 07

## APRES
## L'ACCELERATION

## CAN (CENTRE D'ART
DE NEUCHATEL)
RUE DES MOULINS 37
2001NEUCHATEL
+
## HALLE DE L'ANCIEN
KARTING (SUCHARD
RUE DE TIVOLI 11
2003 NEUCHATEL-
SERRIERES

HORAIRES: MER = 14H00 – 18H30 /
JEU = 14H00 – 20H00 / VEN = 14H00 – 18H30
SAM + DIM = 12H00 – 17H00

Lorsque l'on parle d'accélération, on pense souvent au pilote de
Formule 1: il appuie sur le champignon et la force prodigieuse de son
moteur le plaque contre son siège-baquet. Quiconque est déjà monté
dans une Ferrari ou autre monstre propulsé par moteur à explosion
a déjà expérimenté cette sensation étourdissante: le corps semble
écrasé par son propre poids. Lorsque le skieur franchit le portillon
de départ de la célèbre Streif de Kitzbühel, la descente la plus rapide
et éprouvante du monde, il parcourt les premiers 100 mètres en
moins de quatre secondes, une accélération comparable à celle d'une
Porsche, modèle sport. Mais dans le cas du descendeur, l'accélération
est produite non par des forces extérieures (un véhicule), mais par
le propre corps du skieur, qui, s'il éprouve des forces pouvant aller
jusqu'à 3G, ne ressent pas les pressions d'une accélération «subie». «Tu
ne la ressens pas parce c'est ta propre masse qui produit l'accélération
et qui se déplace» précise un ancien coureur. Si sur la majeure partie
de la course, le descendeur glisse sur la neige (ou le plus souvent
sur la glace) en tentant d'opposer la moindre résistance au vent, il
«tombe» véritablement sur le premier tronçon et joue avec les forces
gravitationnelles (tout corps qui tombe est en état d'apesanteur).
J'aime à imaginer que les spectateurs confrontés pour la première
fois dans leur existence à un *ready-made* de Marcel Duchamp ont

132    20 25    MEHDI BELHAJ KACEM

MEHDI BELHAJ KACEM    21 25    133

Pink Panties

Accélération

Noémie Gygax, Yann Do/no-do

www.no-do.ch

Books and poster for a
contemporary art exhibition. After
reviewing the colors of the Pantone
palette, the authors of this work
considered pink to be perfect for
realizing the idea they had in mind.

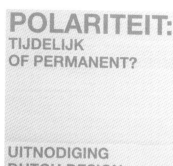

Strawberry Milkshake
Dutch Design Center Initiative
Studio Laucke
www.studio-laucke.com

Invitations for a series of readings concerning design organized by the Dutch Design Center Initiative (DDC-I). For the three invitations, Pantone 673 was used in the first, Pantone red in the second, and black in the third. The same image was re-printed various times to give the impression of superimposed layers.

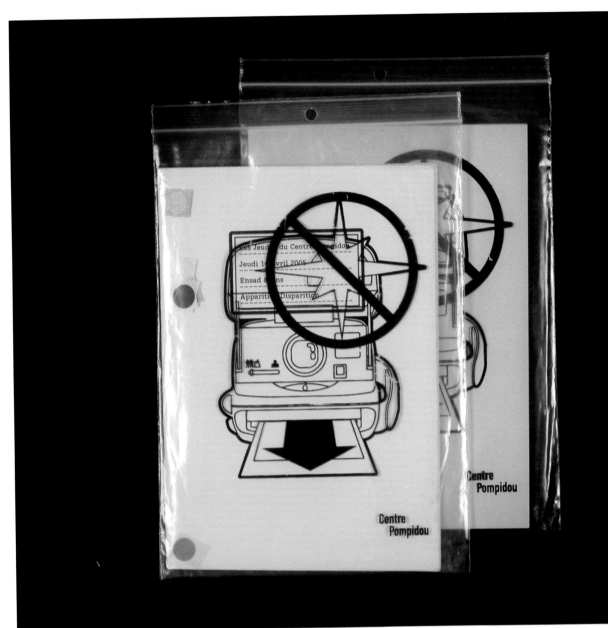

Pink Panther

*Les Jeudis du Centre Pompidou*

Denastas & Chapus

www.denastasetchapus.com

Book for the Centre Pompidou. The
texts are written by students of
the École Normale Supérieure and
accompany the work of students of
Arts Décoratifs. The public took their
own Polaroids and stuck them onto
the book.

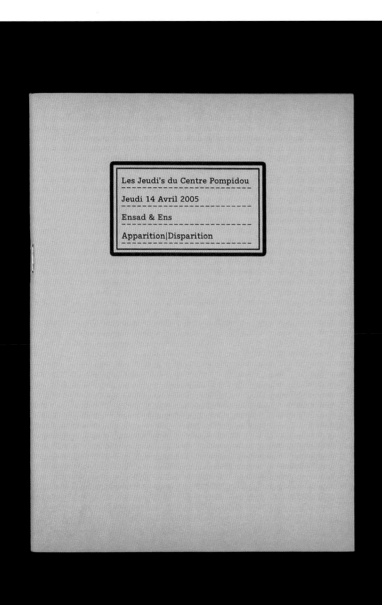

## Sommaire

**Alexandre Chapus,
Emmanuel Pevny
& Vincent Vernet** (3e année design graphique)

Signalétique de la soirée du jeudi 14 Avril 2005

**From Velvet Morning
to Canadian Sky**

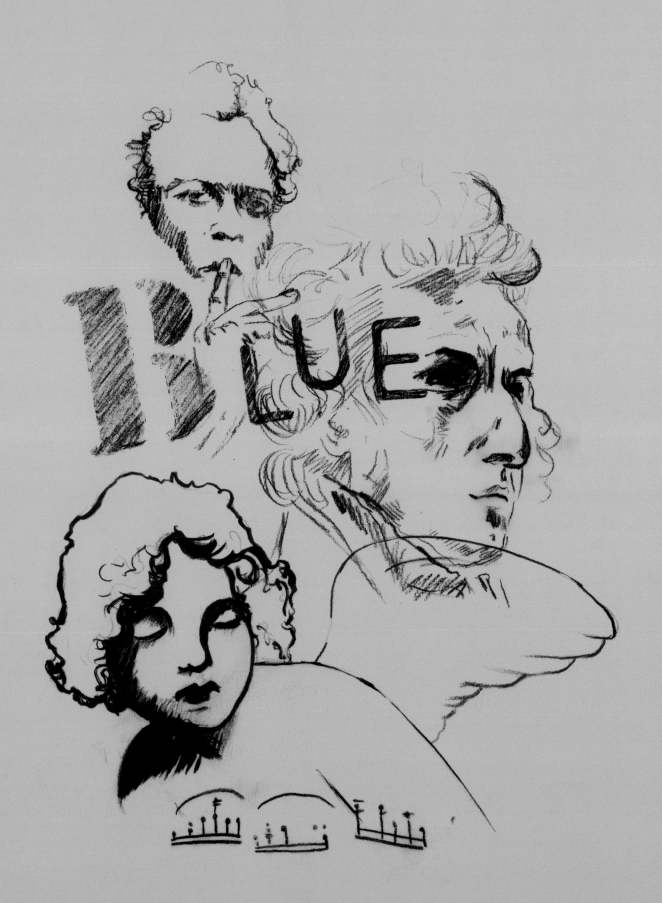

It was essential in the creation of the world. Perhaps for this reason it is the most cherished of all colors. Seeing it in the sky or in the ocean, one would say its height is that of giants. It holds no prejudices, despite preserving in its gaze the entire history of humanity.

The gods rock in its arms.

It becomes claustrophobic in closed spaces, but expands, multiplying to infinity, when stepping out into the open sky. Keeping secrets is challenging for it: it is not designed for confidences, but for the free and naked truth. It scorns nothing more than an infidelity.

Such a sterling résumé, however, does not excuse its faults. Sometimes it is frigid in its treatment of the other colors. Its demeanor tends to be distant, particularly with respect to its complementary color Red, with whom it shares a no more than cordial relationship, avoiding any semblance of intimacy when they cross paths on the cover of a book, in a painting, on a flag, or in the delirium of some ephemeral fashion.

Though it is a paradox, its voice is sad. While it celebrates life every instant, it pities it as well. And it does so with the voice of a defeated man who now has nothing to lose. It wasn't planned: one night it emerged from the throat of a black slave—cracked, wounded, in pieces—and became popular in hundreds of voices and thousands of songs consisting of two or three chords and a handful of raw lyrics. Years later, the grandchildren of those men could say with pride: this is the Blues.

It claims as its own the Nocturnes of Chopin, the voice of Nick Drake, and two or three Miles Davis records, as well as the verse of W.H. Auden and Rubén Darío. It has been the inspiration for countless films, but if it is forced to choose, always opts for Kieslowski's *Bleu*.

Its most famous statement: "I encompass all horizons."

Velvet Morning

Forever Blue

Royal Blood

Stormy Weather

Childhood

Arctic Blue

Blue Sky

Blue Princess

Dolphin Dance

Dusty Turquoise

Blue Eyes

Rainy Day

Saint-Tropez

Tanger Room

Paris Blue

Breeze of Change

Blue Danube

Canadian Sky

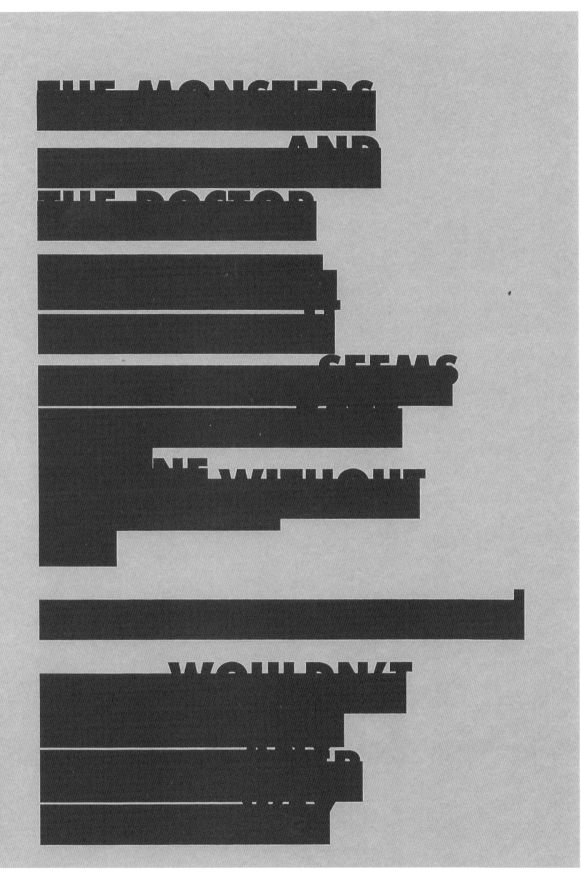

**Velvet Morning**

Doctor Who vs Type
Thorbjørn Ankerstjerne
www.ankerstjerne.co.uk

This work in which blue letters stand out against a gray background belong to a series of posters designed for special effects and the use of electronic music in the series *Doctor Who*.

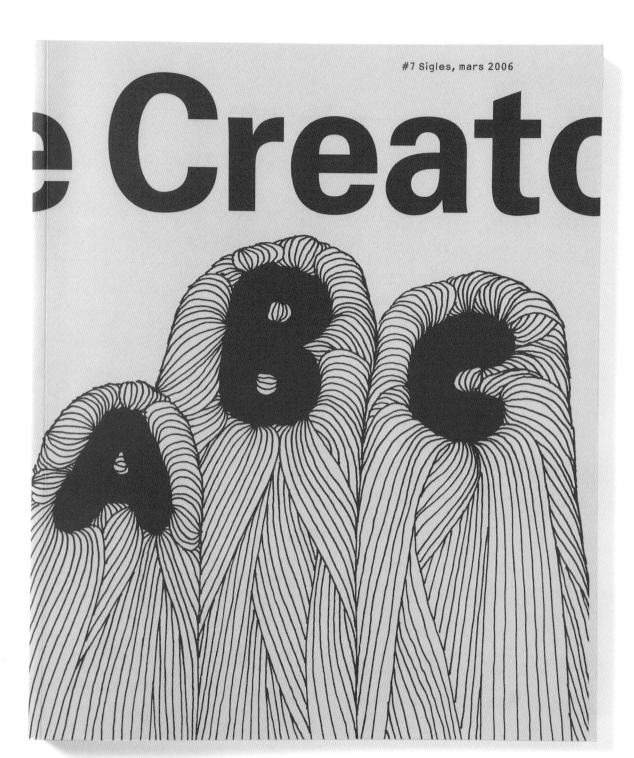

**#7 Sigles, mars 2006**

Forever Blue

*The Creator Studio*
Estudio Rosa Lázaro/La habitación
ediciones
www.rlazaro.com

Monographic art and design
publication based in Barcelona but
that serves as a stepping stone
to an international scale, bringing
together the work of authors from
around the world. It uses color as a
nexus for different elements.

# Oll Korrekt

Par Mevis & Van Deursen

Un sigle universel aux étymologies multiples et légendaires. De son origine possible issue du mot « okeh », puisé de la même signification dans la langue indigène américaine Choctaw, à l'explication apocryphe dérivée de l'expression « 0 Killed » (zéro tué) employée après une bataille sans perte humaine, durant la guerre civile américaine. Cependant, l'explication la plus authentique est celle du professeur de l'université de Columbia, Allen Walker Read (1906-2002). OK serait une abréviation satyrique de « Oll Korrekt », « Tout Correct », en anglais mal écrit. Elle est apparue pour la première fois, selon la mode journalistique de l'époque, dans le Boston Morning Post, en 1883.

Armand Mevis & Linda Van Deursen se sont peut-être inspirés de l'origine journalistique du sigle et ont transformé le New York Times en Ok Times. À partir d'un exemplaire d'un jour déterminé, ils ont découpé les mots et les lettres du titre pour obtenir un nouveau nom, avant de refaire en cinq étapes l'édition de la première page, en l'habillant de nouvelles sans importance et légères tirées de la quatrième de couverture. « Comme s'il pou-

vait exister un journal comme le « Ok Times », où il n'y aurait pas de guerres, pas de terrorisme, pas de tremblements de terre, uniquement des choses complètement innocentes à reporter. C'est quelque chose qui ne pourrait jamais arriver, c'est pourquoi nous avons voulu faire cet exercice, et voir quel effet cela donnerait sur un journal comme le New York Times ».

Linda et Armand travaillent ensemble depuis 1987, après avoir obtenu leur diplôme de la « Rietveld Academie » d'Amsterdam. Leur studio, figure indiscutable du design actuel, fut chargé de concevoir plusieurs projets : l'identité visuelle de « Rotterdam 2001, Capitale Culturelle d'Europe », des timbres pour la poste hollandaise (PTT Post) et des catalogues pour de nombreux artistes et designers, comme Victor & Rolf. Leurs travaux ont été publiés dans Idea, IdN, Eye, I-D, Typography Now, HQ, et Graphic Design for the 21st Century, et exposés en Belgique, au Japon, en France, en Allemagne, en Angleterre et aux États-Unis. Ils sont tous les deux enseignants dans de prestigieuses institutions des Pays-Bas et de l'EUA.

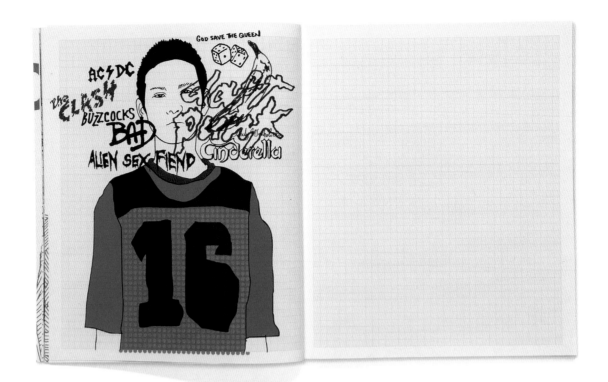

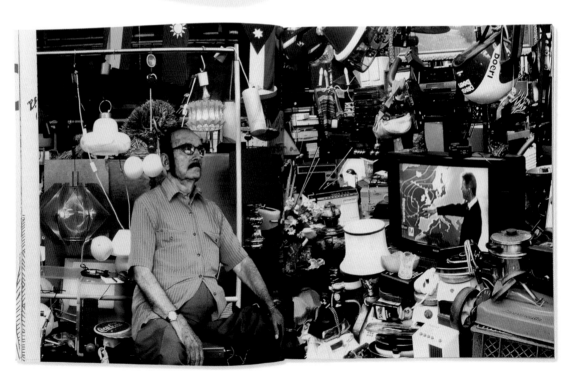

Royal Blood

15º

Giuliano Garonzi/

Happycentro+Sintetik

www.hs-studio.it

Graphic designs for products
(T-shirts, balls, knapsacks) for the
Nike store in Milan, in addition to
a limited edition poster and web
animations to mark the victory of
Internazionale Football Club in the
Italian league.

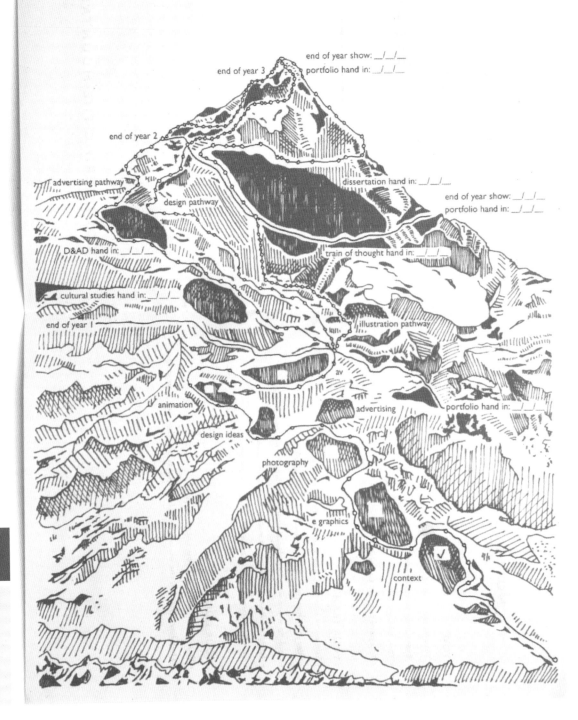

# A GUIDE TO YOUR JOURNEY

end of year show: __/__/__
portfolio hand in: __/__/__

end of year 3

end of year 2

advertising pathway

design pathway

dissertation hand in: __/__/__

end of year show: __/__/__
portfolio hand in: __/__/__

D&AD hand in: __/__/__

train of thought hand in: _____

cultural studies hand in: __/__/__

end of year 1

illustration pathway

av

animation

advertising

portfolio hand in: __/__/__

design ideas

photography

e graphics

context

**Stormy Weather**
*Conquering the Mountain*
James Musgrave
www.jamesmusgrave.com

Cyan and magenta serve as basic references in this project, a guide for completing the university qualification in Graphic Design at Central Saint Martins College of Art and Design of London (United Kingdom).

# CENTRAL ST MARTINS

# A DEGREE IN

# GRAPHIC DESIGN

---

## CONQUERING THE MOUNTAIN

## NOTES ON YOUR CLIMB

### YOU

- Your vision of the top is the greatest asset you have.
- Every step you take you will have to make on your own.
- Your energy alone will carry you to the top.
- You have to start to finish.

### YOUR TEAM

- Someone else's weakness could be your strength.
- Everyone has their own approach to their journey.
- Look to those who have faced similar problems on other climbs.
- Together we encourage and inspire each other upward.
- Climbers from different regions each climb differently

### YOUR GUIDES

- Your tutors will guide you, not carry you.
- They have climbed the mountain before that is why they are your guide.

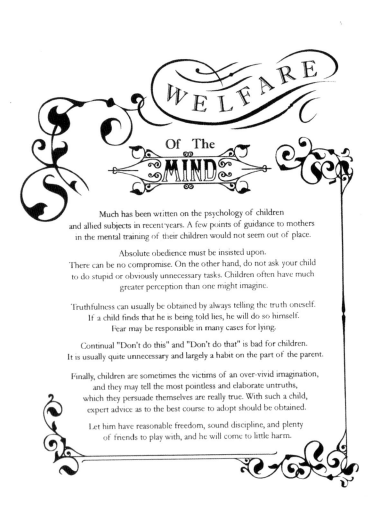

## WELFARE
### Of The
## MIND

Much has been written on the psychology of children and allied subjects in recent years. A few points of guidance to mothers in the mental training of their children would not seem out of place.

Absolute obedience must be insisted upon. There can be no compromise. On the other hand, do not ask your child to do stupid or obviously unnecessary tasks. Children often have much greater perception than one might imagine.

Truthfulness can usually be obtained by always telling the truth oneself. If a child finds that he is being told lies, he will do so himself. Fear may be responsible in many cases for lying.

Continual "Don't do this" and "Don't do that" is bad for children. It is usually quite unnecessary and largely a habit on the part of the parent.

Finally, children are sometimes the victims of an over-vivid imagination, and they may tell the most pointless and elaborate untruths, which they persuade themselves are really true. With such a child, expert advice as to the best course to adopt should be obtained.

Let him have reasonable freedom, sound discipline, and plenty of friends to play with, and he will come to little harm.

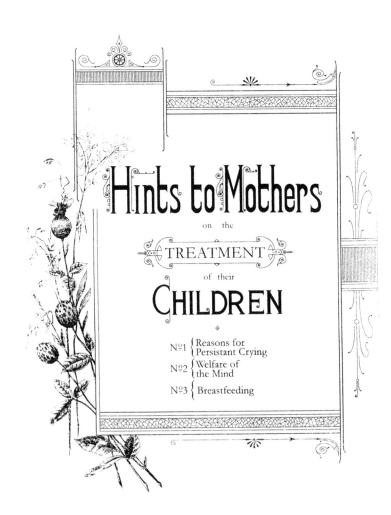

## Hints to Mothers
on the
### TREATMENT
of their
## CHILDREN

Nº1 { Reasons for Persistant Crying

Nº2 { Welfare of the Mind

Nº3 { Breastfeeding

**Childhood**

*Hints to Mothers*
Theo Wang, Tom Boulton/Sort Design (Society of Revisionist Typographers)
www.sortdesign.com

Project that bases its style on different guides and manuals from the period between the end of the 1800s and 1930, maintaining the aesthetic and craftsmanship of the time. Cream yellow complements deep blue.

# REASONS 4 PERSISTENT CRYING

He is in pain; He is hungry or thirsty; He feels hot and sweaty; He is being over-stimulated; He is wet or dirty and needs to be changed; He feels lonley and neglected and needs a little cuddling; He wants to be turned over to a more comfortable position;

Arctic Blue

*An Initiation in Typography*
Anne Denastas, Camille Gallet/
Denastas & Chapus
www.denastasetchapus.com,
www.camillegallet.fr

Book that explores the worlds of
visual design and topography. The
first chapter deals with proportions,
the second with the tension between
black and white, and the third
with the origin of characters and
typographic families.

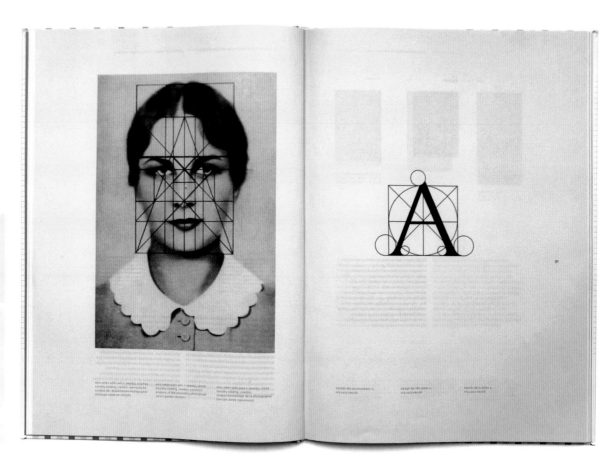

beim ausgleichen bestimmt man die abstände zwischen den buchstaben, man kann damit aber auch die länge der textzeile verändern. je nachdem welche ausrichtung man für den textblock gewählt hat, kann man eine zeile enger oder weiter setzen und auf diese weise eine ausgewogene grauverteilung erreichen. im 15. jahrhundert schnitt gutenberg die buchstaben unterschiedlich breit, um so eine perfekte ausgewogenheit seines satzblocks zu erreichen und zeilen gleicher länge zu bekommen. er imitierte damit die handschrift mit ihren gleichmäßigen zeichenabständen.

while tracking is meant to adjust the spacing between letters, it also influences the length of the line of text. you can squeeze or stretch a line in accord with the mode of justification chosen for the block in order to obtain an even texture. in the 15th century, gutenberg designed certain letters in a range of sizes in order to be able to set blocks having lines of perfectly equal length. in this he imitated the practice of scribes, who kept the spacing between words constant.

l'interlettrage règle l'espace entre les lettres, mais il permet aussi de varier la longueur de la ligne de texte. on peut resserrer ou élargir une ligne, suivant la justification que l'on a choisie pour son bloc de texte, afin d'obtenir une répartition équilibrée. au 15e siècle, pour obtenir une justification parfaite de son bloc de composition, gutenberg a dessiné certaines lettres en différentes largeurs pour obtenir des lignes de texte de la même longueur. il imite en ceci l'écriture manuscrite qui conserve un espacement égal entre les mots.

the white point and the black point have the same diameter, but the white point appears to be larger than the black one. the white point appears to be in the background, like a hole, while the black point opens like a knob, placed in the foreground.

le point blanc et le point noir ont le même diamètre, et le point blanc paraît plus gros que le point noir. le point blanc semble placé au second plan, comme un trou, alors que le point noir est comme une pastille placée au premier plan.

mit der weiterentwicklung des buchdrucks entstanden neue notwendigkeiten. die weniger aufwändige, da immer stärker mechanisierte buchherstellung erlaubte eine diversifizierung von inhalten und leserschaft. auf der suche nach methoden des seitenlayouts, die einen funktionellen und variablen umgang mit dem raum ermöglichten, entdeckten typographen wie jan tschichold und karl gerstner zu beginn des 20. jahrhunderts die mittelalterlichen ordnungslinien wieder und interpretierten sie neu. die heutige, ökonomisch bedingte notwendigkeit einer maximalen ausnutzung des papiers verdrängt das villard'sche schema mit seinen breiten rändern. die verwendung von ordnungslinien ist mittlerweile eher nebensächlich geworden. stattdessen wird häufig mit einem raster gearbeitet, das unmittelbar von den mittelalterlichen prinzipien der seitenaufteilung abgeleitet ist.

with the development of printing, the book acquired new needs. its fabrication, less tedious because more mechanized, now permitted a wider range of contents and of readers. at the onset of the 20th century, typographers like jan tschichold and karl gerstner rediscovered the medieval guide rules and reinterpreted them. their initiative took place in the context of a search for principles of layout that would permit functional use and modularization of the book's space. modern economic constraints exert pressure to use as much of the printable area as possible. and they make it difficult to use the rules of villard de wonnecourt with his large margins. thus, the use of regulating layout lines has become marginal in our time. on the other hand, the layout grid, derived directly from medieval principles for division of the page, is a widespread tool.

avec l'évolution de l'imprimerie, le livre connaît de nouveaux besoins. sa fabrication, moins onéreuse car de plus en plus mécanisée, permet une diversification du contenu et des lecteurs. au début du 20e siècle, des typographes comme jan tschichold et karl gerstner redécouvrent les tracés médiévaux et les réinterprètent. leur démarche s'inscrit dans un contexte de recherche de principes de mise en page qui permettent une utilisation fonctionnelle et modulable de l'espace. les contraintes économiques actuelles et avec elles, la nécessité d'une occupation maximale du papier, rendent peu utilisable le tracé de villard de wonnecourt avec ses larges marges. l'utilisation des tracés régulateurs est de nos jours très marginale. en revanche l'emploi de la grille, directement hérité des principes médiévaux de division de la page, est largement répandu.

... dass zwischen kunst und typographie gewisse verbindungen bestehen?

... certain similarities between art and typography?

... certaines correspondances entre l'art et la typographie?

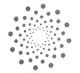

the philosophers and artists of ancient times noticed that certain structures recur, lending beauty to the universe everywhere. they looked for geometric and mathematical foundations of these structures, and concluded that there exist in the very depths of nature certain values that establish harmonious relations between a whole and its parts. in the west, the greeks were the first to study the formal conditions of beauty and to find connections between them and a universal order founded on measure and proportion. the pythagoreans, later plato, described the order of nature in terms of mathematical structure. this line of thought was taken up again in the european middle ages and renaissance, which continued the search to discover and comprehend the harmonies perceived in nature.

des penseurs et artistes de l'époque antique ont remarqué que, dans l'univers, certaines structures sont récurrentes et source de beauté. ils ont recherché les fondements mathématiques et géométriques de ces structures. ils en ont conclu qu'il existe des valeurs qui établissent un rapport harmonieux entre les parties d'un ensemble au sein même de la nature. les grecs sont les premiers, en occident, à rechercher les critères de la beauté et à les mettre en rapport avec un ordre universel fondé sur la mesure et la proportion. les pythagoriciens puis platon pensent l'organisation du monde selon une structure mathématique. cette pensée va influencer le moyen âge et la renaissance, qui ne cesseront de chercher à découvrir et à rationaliser l'harmonie perceptible dans la nature.

from this mathematical conception of beauty arose a theory of form that put the golden ratio at the heart of every relation of harmony. its value is exactly $(1+\sqrt{5})\div2$, or 1.618. it establishes the relation between two unequal values, such that the ratio of the smaller value to the larger is the same as that of the larger to the sum of the two. the presence of this ratio in the proportions of plants and in human anatomy thus reveals a divine, pre-established harmony between man and the universe. it was therefore called the "divine ratio" in the renaissance, being seen as bearing the imprint of the creator's thought. where antiquity regarded human proportions as the point of reference for the harmony of the universe, with the renaissance, human proportions served to inspire architecture.

de cette conception mathématique de la beauté naît une théorie de la forme qui place le nombre d'or au cœur de toute harmonie. il a pour valeur exacte $(1+\sqrt{5})\div2$ soit environ 1,618. cette valeur établit le rapport entre deux grandeurs inégales quand la plus petite est à la plus grande ce que la plus grande est à la somme des deux. la présence du nombre d'or dans les proportions végétales et humaines semble ainsi manifester l'existence d'une harmonie préétablie entre l'homme et l'univers qui relève du divin. il est baptisé « divine proportion » à la renaissance, car il est considéré comme la traduction de la pensée du créateur de l'univers. l'antiquité considère le corps humain comme la référence de l'harmonie universelle ; avec la renaissance c'est la structure de l'homme qui sert d'inspiration à l'architecture.

Blue Sky

*Clark Magazine*

Steven Harrington

www.stevenharrington.com

Cover for *Clark Magazine*, a French magazine of urban culture, graphic design and music. A sky blue pushed into the background cedes protagonism to other colors.

LUCKY NUMBER 25

CLARK MAGAZINE

MAI-JUIN 07

# CLARK

STREET CULTURE  GRAPHISME  MUSIQUE

5.00 € #25

132 PAGES

Steven Harrington

*Steven Harrington*

JUSTICE • NU WHAT? • ARTUS • YONE
BOWLING CLUB • STEVEN HARRINGTON
BOYSNOIZE • SIMIAN MOBILE DISCO

0 92567 10860 2    04>

Blue Princess
Visual
Martin Lorenz/Twopoints.Net
www.twopoints.net

All the colors that CMYK offers were used in this illustration published in the magazine *Visual*, which devoted a lengthy article to Twopoints.Net. The studio shows part of its garden with a combination of techniques and colors, among which blue stands out.

**Dolphin Dance**

*The Myth Series Book Jacket Designs*
Matteo Bologna, Jeffrey Fisher/
Mucca Design
www.muccadesign.com

This series of books narrates ancient myths that have been rewritten by contemporary authors. An antiquated typography was consciously employed, though the illustrations that accompany it are of different contemporary styles.

**Dusty Turquoise**

*Il Nome di Marina*
Matteo Bologna, Jean-Marc
Troadecil/Mucca Design
www.muccadesign.com

The blue waves of the
Mediterranean and handmade
typography are the protagonists
of the cover of this simultaneously
realistic and magical novel set in
Italy next to the sea, in Matina di
Melilli.

Blue Eyes

Gris (Collection)
Denastas & Chapus
www.denastasetchapus.com

Gris forms part of a collection of
books. The covers change with each
one, but all the interiors are printed
in black and white. The objective is
to discover the differences between
one book and another.

EVERY CLOUD HAS
A SILVER LINING

Rainy Day

*Every Cloud Has a Silver Lining*
Noémie Gygax, Yann Do/no-do
www.no-do.ch

Vinyl designed for the album *Every Cloud Has a Silver Lining*. Starting with the music on the record as a source of inspiration, the creators of this design opted for pastel blue for the cloud, a key element in the work.

Saint-Tropez

Cesda

Otto&Olaf

www.otto-olaf.com

Image for a university center for advanced aviation studies in Reus (Tarragona). The sky and ocean blues are appropriate given the subject matter.

¿Quieres ser piloto?

cesda.com

**Cursa en CESDA tus Estudios Universitarios Superiores de Aviación!**

Graduado Superior en Aviación Comercial. Piloto de Transporte de Líneas Aéreas.

Graduado Superior en Gestión de Empresas Aeronáuticas y Operaciones Aéreas

Oferta formativa On-line para pilotos profesionales.

**Campus Aeronáutico de Reus Tel. 977 300 027**

**CESDA**
Centre d'Estudis
Superiors de l'Aviació
European University College of Aviation

**Tanger Room**

Sally Scott In-shop Poster
Atsuki Kikuchi/Bluemark
www.bluemark.co.jp

Sally Scott is an exclusive brand of
Japanese clothing for women. These
posters maintain this character,
though the colors, liberally inspired
by day and night, have been carefully
modified.

A SWEATER FOR THE WORLD!
by ANTOINEPETERS presents

ONE SWEA-
TER

Fri. 26 January 2007
Exhibition      1400      00 HR
Opening word      1600  HR
Oostelijk Meterhuis  Building 2)
Amsterdam      Westergasfabriek.nl

Information & press   IMAGO FACTORY
+31(0)20-42 12  24
manuel@imagofactory.com

asweaterfortheworld.com

PHILIPS

AMSTERDAM
INTERNATIONAL
FASHION
WEEK

Paris Blue

Onesweater Invitation Series
Karen van de Kraats
www.karenvandekraats.com

"A Sweater for the World" is a
project of fashion designer Antoine
Peters. She photographed people
from all over the world in a sweater
designed for two. The colors she uses
are those of her corporate image.

Poster for a theatrical comedy
*Quel Profumo di Mandarini*. Cyan
and black were used to inscribe
information about the work within
the area of the character's face.

Blue Danube

Fleetwood Mac

Marcus Oakley

www.marcusoakley.com

Self-promotional work by the author.
A combination of pastel and bright
colors. The objective was to create
a fresh and relaxed atmosphere,
accentuated here by the two shades
of blue that are predominant in the
work.

BROKEN SOCIAL SCENE

MANCHESTER ACADEMY FEBRUARY 14 £8.50

RGG107 WWW.RICHARDGOODALLGALLERY.COM

Canadian Sky

Broken Social Scene

Jason Munn

www.thesmallstakes.com

Poster for a concert of the
Manchester group Broken Social
Scene. Black and blue are used.
Blue is used for the group's name
in order to focus attention on it.
The rest of the image is a figure in a
scene meant to be read as a whole.

**From MS-DOS Green to Foliage**

green

The rebel of the family. Untamed and free, it is like a cat: it lets himself be caressed but not domesticated, and rarely does it lose its composure. It is an elegant rebellion, austere, without the desperation of James Dean or the utopias of John Lennon. In fact, it has always felt more akin to the elusive Rimbaud.

It believes in just causes, in home remedies, in the goodness of sports and the value of nature.

More than a color, it is a philosophy. Yet its prestige and apparent self-confidence do not spare it from doubt or the scruples typical of people of the left. And since it is accustomed to lost causes, it is believed to possess an iron will.

A piece of information: when there is a dispute between two or more colors, it is sought out as a mediator. It is always listened to with attention and reverence, and nobody questions its judgment. It has the best of youth—lack of prejudices and freshness of reasoning—and the best of maturity—experience.

A secret: sometimes, without its having done anything to bring it about, a spontaneous and terrifying cry bursts out from the depth of its heart, a clamor capable of crushing stones. When it knows that it is alone it allows it to escape, unable to contain its tears. Few are capable of recognizing this cry traversing the air and cutting through valleys, cities, mountains, entire countries . . .

When the leaves of a tree shudder or a cat sees something imperceptible to us, at this moment the cry is passing through them.

It likes the feel of silk and St. Patrick's Day.

Its most famous statement: "There is time for everything."

MS-DOS Green

Soft Jade

Country Dreams

Emerald Green

Ecologic Green

Green Spotlight

Austrian Grass

Glimmer of Hope

Sweet Fish

Lime & Lemon

Jell-O Green

Kiwi

Foliage

**Recipe «Tortilla de patatas»**
or Martin teaches Kasper how to do a «Tortilla de patatas».
*Barcelona, 2006*

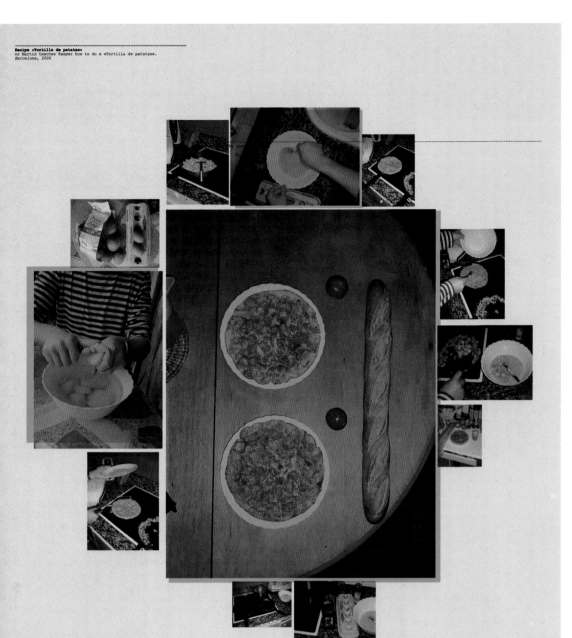

Step one:

- Peel 5 medium sized potatoes
- Cut them into small cubes
- Fry them in a lot of olive oil until they are done

Step two:

- Mix six eggs
- Add fried potato cubes
- Add salt

Step three:

- Remove oil from pan
- Add this time only a little olive oil
- Wait until it is hot
- Add the egg-potato mix
- Once the egg starts to stiffen shake the pan a little sideways, so the tortilla doesn't stick
- Turn down the heat
- When the bottom half of the tortilla has become stiff, cover the pan with a plate, turn it upside down and slide the tortilla back into the pan

Buen provecho de parte de:

y:

**MS-DOS Green**

Tortilla de Patata
Martin Lorenz/Twopoints.Net
www.twopoints.net

Limited edition poster by Kasper Riisholt. Two Pantone colors were used: dark gray and green. It documents a cooking class with photographs illustrating how to make a Spanish omelette.

Matinés 60 x 60

Miquel Polidano

www.miquelpolidano.com

Image from the concert cycle *Matinés 60 x 60*, a festival that revives the idea of morning concerts from the sixties. The posters have two texts: one in black letters and the other in different colors for each concert.

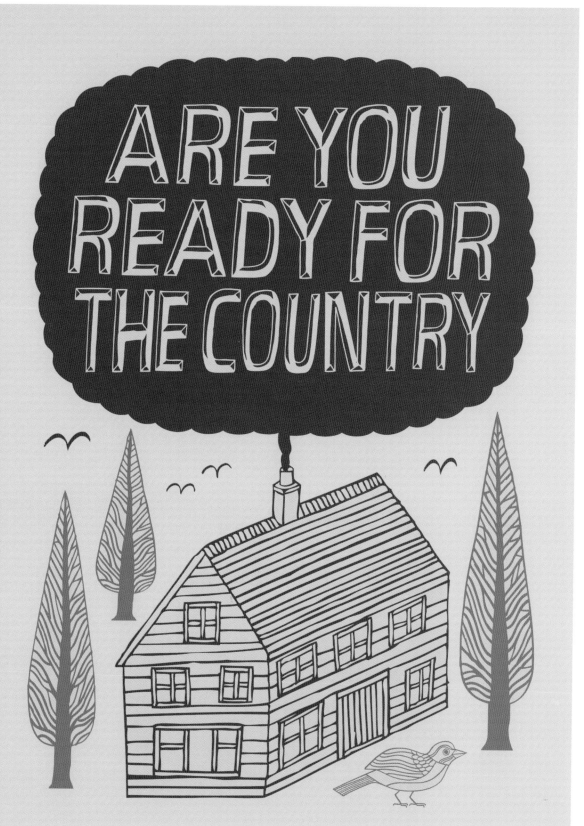

Country Dreams

Wood House with Bird

Marcus Oakley

www.marcusoakley.com

Self-promotional work of the author in which the combination of pastel and bright colors—in this case, purple and blue against a pale green background—create a fresh and relaxed atmosphere.

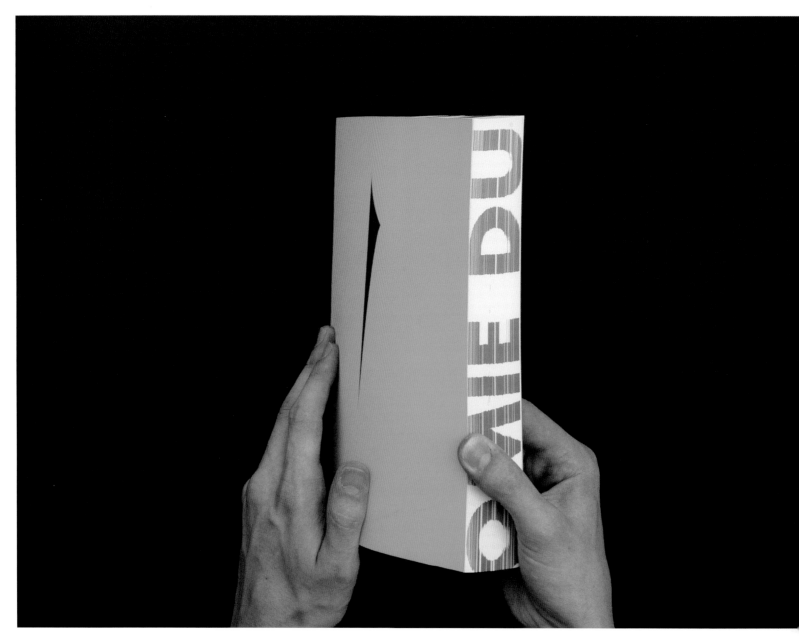

Emerald Green

*Anatomie* (Collection)

Denastas & Chapus

www.denastasetchapus.com

*Anatomie* forms part of a collection
of books. The covers change with
each one, but all the interiors
are printed in black and white.
The objective is to discover the
differences between one book
and another.

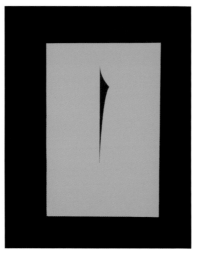

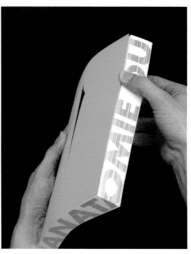

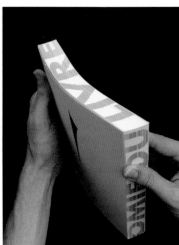

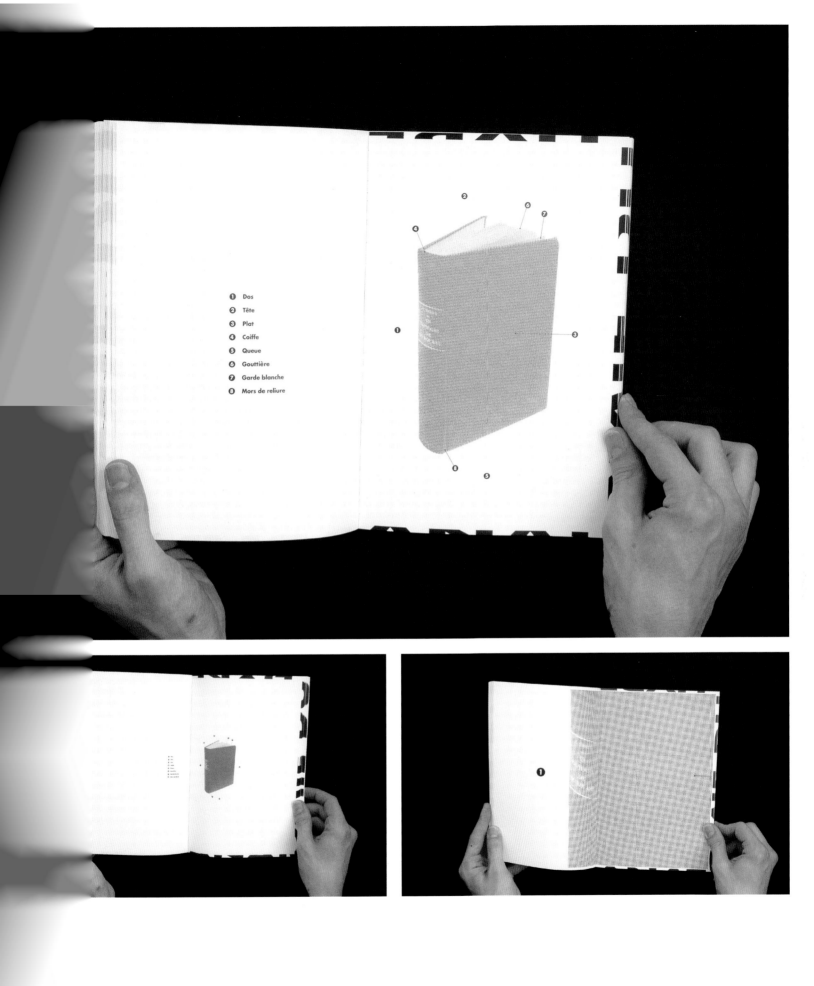

1. Dos
2. Tête
3. Plat
4. Coiffe
5. Queue
6. Gouttière
7. Garde blanche
8. Mors de reliure

Ecologic Green

¿Basura?

Marc Català, Pablo Juncadella/Mucho

www.mucho.ws

Promotional flyer by Demano for
Bread & Butter Barcelona. It
consists of an easily recognizable
piece of crumpled paper of a
basic color related to the theme of
recycling.

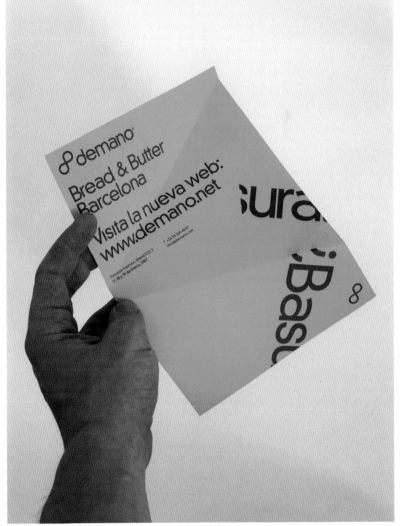

Green Spotlight

*Verdades a Medias, Medias Verdades*

Carles Rodrigo/Eina. Escola de Disseny i Art

Exercise for lithography subject. The task was to design a book. Through the superimposition of inks and supports, a dialectical game is established in which the different fragments of information overlap.

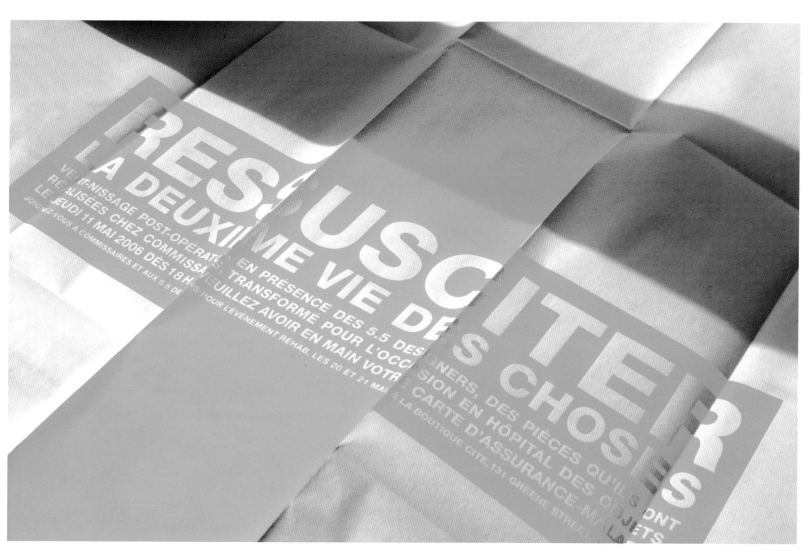

**Austrian Grass**

*Ressusciter*

René Climent/Paprika

www.paprika.com

Poster for the exhibition "Ressusciter," where a group of designers granted various projects a second life. Green was elected to connect with the color of French hospitals and pharmacies. The cross alludes to the biblical idea of resurrection.

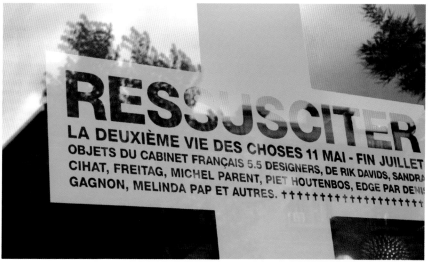

**Glimmer of Hope**

Cat Lamb Poster

Mansi Shah

www.mansishah.com

Cover for a book series for The Directors Bureau Sketchbooks. Colors that contrast with each other, that challenge and collide with one another, were chosen in order to create visual vibrations and movements that enrich the work.

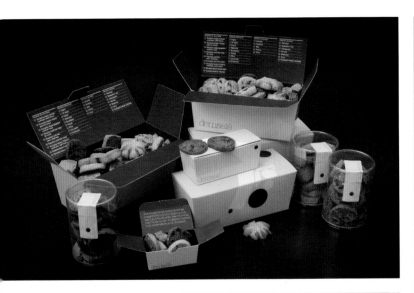

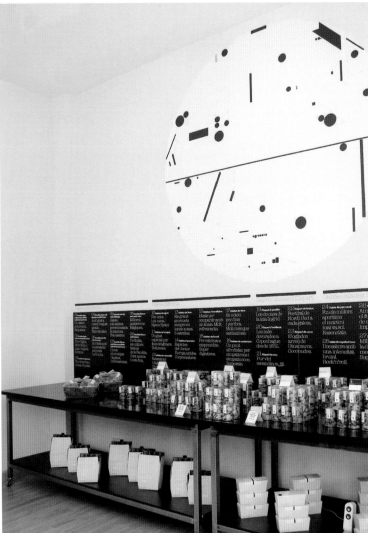

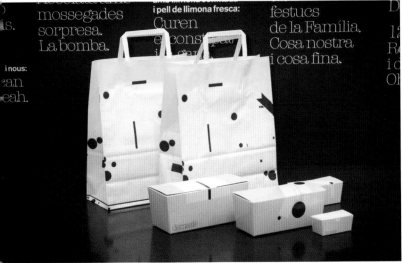

Sweet Fish

Demasié

Marc Català, Pablo Juncadella/Mucho

www.mucho.ws

Image for a cookie chain. A spirited
pastel color was used to define
the personality of the project. The
result is a graphic mural in which
parts are taken out or re-framed in
the creation of an image instead of
repeating the same symbol.

**Lime & Lemon**

women'secret

Daniel Ayuso, Susana Frau, Mirja Jacobs/Cla-se

www.cla-se.com

White completely dominates the exterior, as it does the exteriors of the stores of this clothing brand for women. This contrasts with the use of color for the interior, a metaphor for the richness of the world of women.

secrets/**insights**

## Three inside portraits
a project by **women'secret**

fourteen portraits by **women'secret**

Jell-O Green

Buho
Otto&Olaf
www.otto-olaf.com

Image for the new line of purses by
Vaho, a company whose products
are made exclusively of recycled
flags. Green gives a touch of
glamour to the black background.

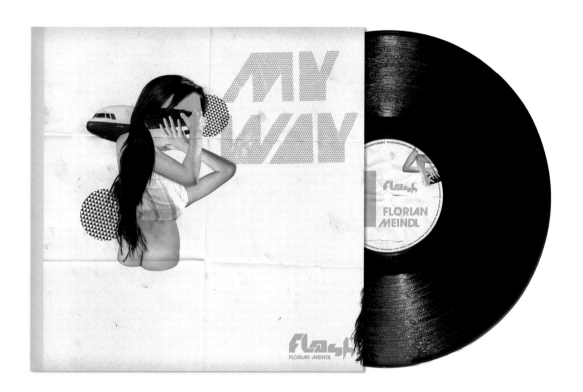

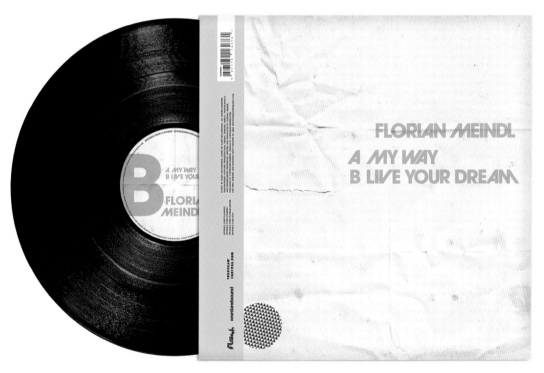

Kiwi

*My Way*

ICE CREAM FOR FREE

www.icecreamforfree.com

Image for an album by the techno
minimal production company Flash
Recordings. Four colors: beige
for the background, green for the
typography, and purple and yellow
for the most prominent elements.
The idea was to create an unusual
but effective combination of colors.

Foliage

Ferienpass 2005

MoiMoi

www.moirajurt.ch

Project for the summer program Ferienpass aimed at children ages 6 to 18. A very simple layout was chosen, using a single typography of uniform size and two colors, green and red, to differentiate the content of each page.

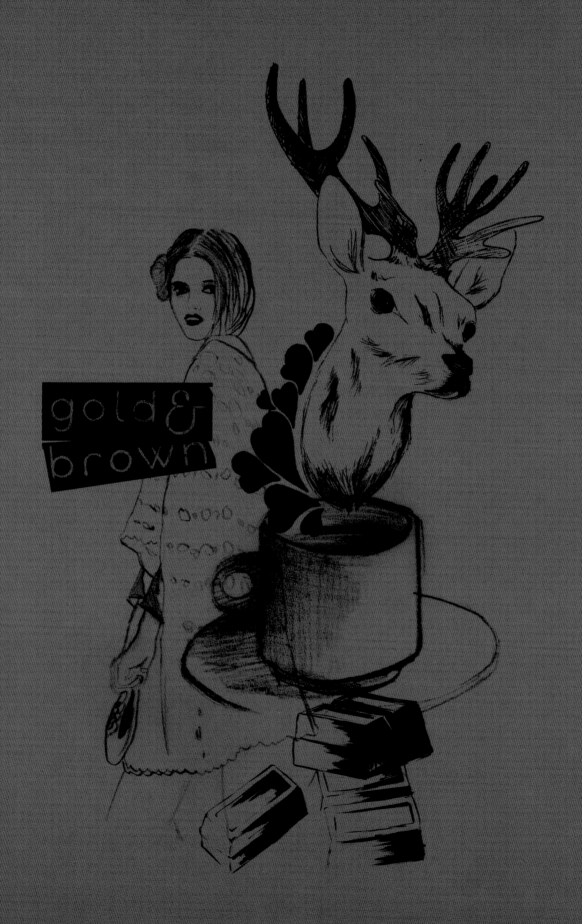

It is always at its peak: when youthful because of its opulence, when old because of its nobility. Of it the wise say, it is the "chord of happiness." Health, Money, Love. It is success and experience, luxury and culture.

Its character is neither open nor accessible. It demands of its companions certain qualities and politeness. Bad manners are anathema to it. It is used to being called pedantic—an accusation which, incidentally, falls on its ears with delight. Never will one see it riding public transport, although it is a regular in libraries: it likes the liturgical silence of these places, the wisdom of the books filling the air around it.

Fame has never gone to its head. It graces winners—in sports, in cinema, in music, in fashion—with a naturalness that seems of another world. It explains it like this: "It is what distinguishes the nouveau riche from old money: savoir faire."

It likes malt whiskey, a fire burning in the hearth, Van Morrison in the background and Oscar Wilde in its hands.

Its most famous statement: "And the winner is . . ."

*

The secret child of the colors. Recently born, and already abandoned. When chance and lust unite blue and orange, green and red, violet and yellow, or any color and black, it is born, illegitimate, poor, unfortunate . . .

Though everywhere, it has yet to find its place in the world.

Its life is one of constant overcoming, and despite all its difficulties, anyone who knows it swears there is no one more honorable, simple, and persevering. It is hardened by adversity and sees itself as a kind of Oliver Twist.

Its most famous statement: "When I'm older, I would like to be . . ."

Old Empire

Deluxe Color

Champagne

Rich Gold

Kitsch Gold

Brownie

Golden Hearts

Sun-Baked Stucco

**Old Empire**

**The Studio by Pro Wolf Master**
**Milkxhake**
**www.milkxhake.org**

The Studio by Pro Wolf Master
is an American shop founded in
Hong Kong. The poster was initially
printed in gold with black typography
and a textured logotype, creating
a harmonious mix of contemporary
graphic culture.

**Deluxe Color**

*Die arabische Nacht*
Erich Brechbühl/Mixer
www.mixer.ch

Theatrical poster for the work *Die arabische Nacht* in which black and gold are the protagonists. Black is used to represent the apartment blocks, while gold serves for the letters of the title of the work.

Champagne

Mola New Year's Greeting Cards
Rui Morais/Mola Ativism
www.mola.ativism.pt

Gold and black were chosen for the
celebration of the New Year that
commemorated the first anniversary
of this graphic design studio.
Gold represents the courage of
people with talent, while black is a
metaphor for professionalism.

THE
GOLDMAN
WAREHOUSE

In the Wynwood Arts District

404 NW 26th St
Miami Florida
33127 US of A

t +1 305 576 5502
f +1 305 576 5503

info@thegoldmanwarehouse.com
www.thegoldmanwarehouse.com

THE
GOLDMAN
WAREHOUSE

404 NW 26th Street
Miami Florida
33127 US of A

info@thegoldmanwarehouse.com
www.thegoldmanwarehouse.com

t +1 305 576 5502
f +1 305 576 5503

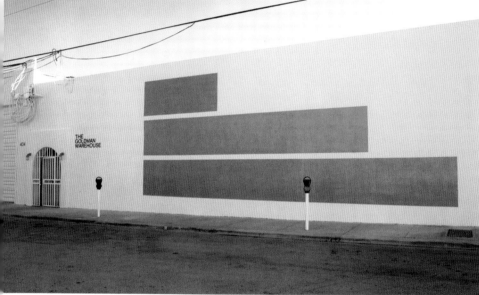

Rich Gold

The Goldman Warehouse
Emmi Salonen, Jan Wilker/
Karlssonwilker inc.
www.karlssonwilker.com

Miami art gallery The Goldman
Warehouse exhibits, above all,
abstract art from private collections.
In this work, black is employed
for the text and gold for the image
of the gallery.

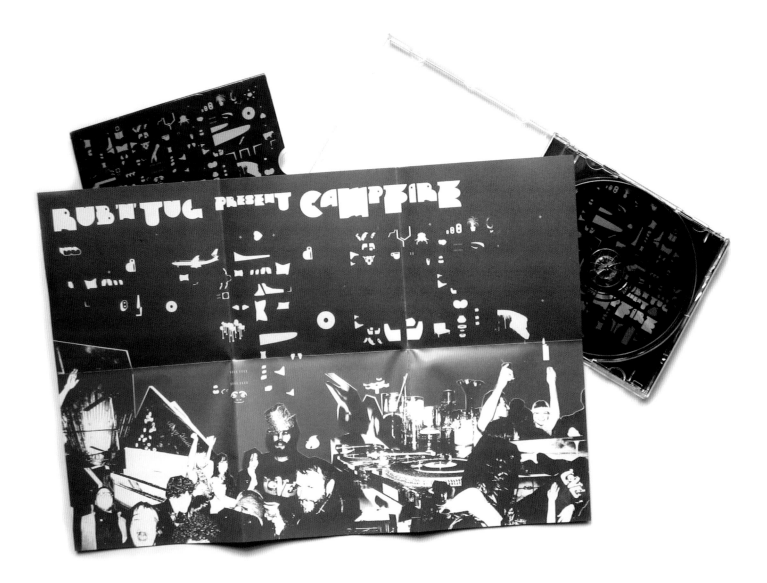

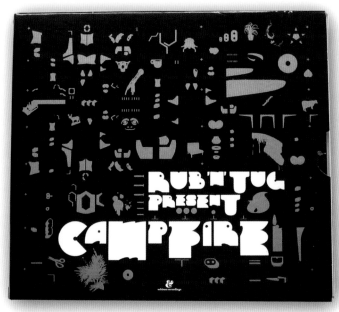

Kitsch Gold

*Rub'n'Tug Present Campfire*
Daniel Bembibre
www.danielbembibre.com

This compilation is an unorthodox mix of disco, rock, funk and electro. Black grants simplicity to the album, calling attention to the different objects in gold that add a touch of kitsch to the arrangement.

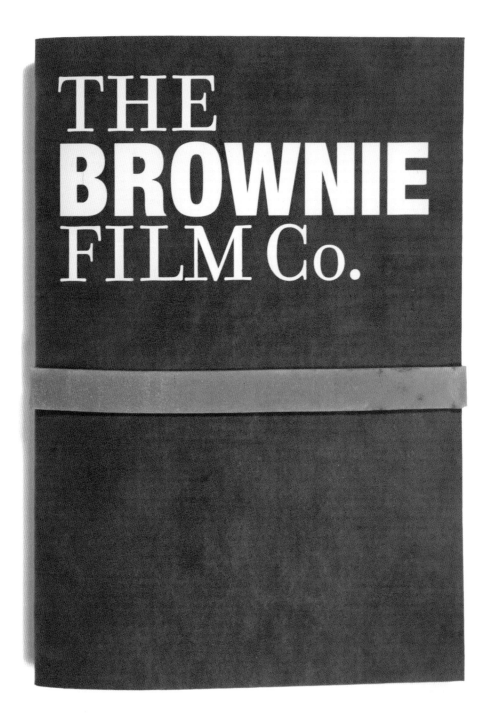

Brownie

The Brownie Film Co.
Emeyele
www.emeyele.com

Corporate image of the film
production company The Brownie
Film Co. The main color, for obvious
reasons, is brown, though it has
been combined with other colors
(such as green, white and black)
that harmonize and complete the
ensemble.

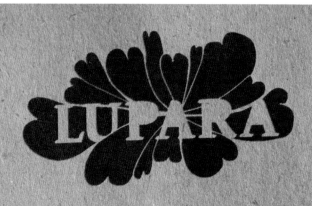

( tapes )

___assortiment d'ibèrics 6.50€, ___assortiment de formatges 6.

___llagostí bullit 6€, ___daus de bacallà marinat amb olivada 5.

___daus de salmó marinat 5.90 €, ___moixama 6.50 €,

___patates 1.40 €, ___olives 1.50 €

( les llaunes espinaler )

___escopinyes 7.50 €, ___musclos en escabetx 5€, ___xipironet

___oli 5€, ___calamars farcits 5€, ___langostillo 5€, ___ventresca

( amanides )

___verda: tomàquet + olives + tonyina 3.50€, ___grega: formatge

+ nous 4€, ___sueca: panses + pinyons + ceba fregida 4€

**Golden Hearts**

Lupara
Vicky Roqué
melleviki.blogspot.com

Corporate image of a bar in Barcelona. *Lupara*, which means literally "wolf-shot," is the name of the sawed-off shotgun used by the Mafia. This project sweetens the connotation through graphic design and the color gold.

**Date Due**

JUN 14 1972

NOV 0 5 1990   MAY 1 1 2006

JUL 15 1997

APR 23 2004

**1000**
CALIFORNIA PLACE NAMES

*Semiotics of*
*So-Cal*

Sun-Baked Stucco

Fantality

Victor Hu

www.victorhu.com

Project inspired by the film *Los Angeles Plays Itself*. The urban contrasts of the city of Los Angeles and its colors worn away by the sun serve as stimuli for the author in the creation of this work.

**From Tokyo Pop**

**to Lego**

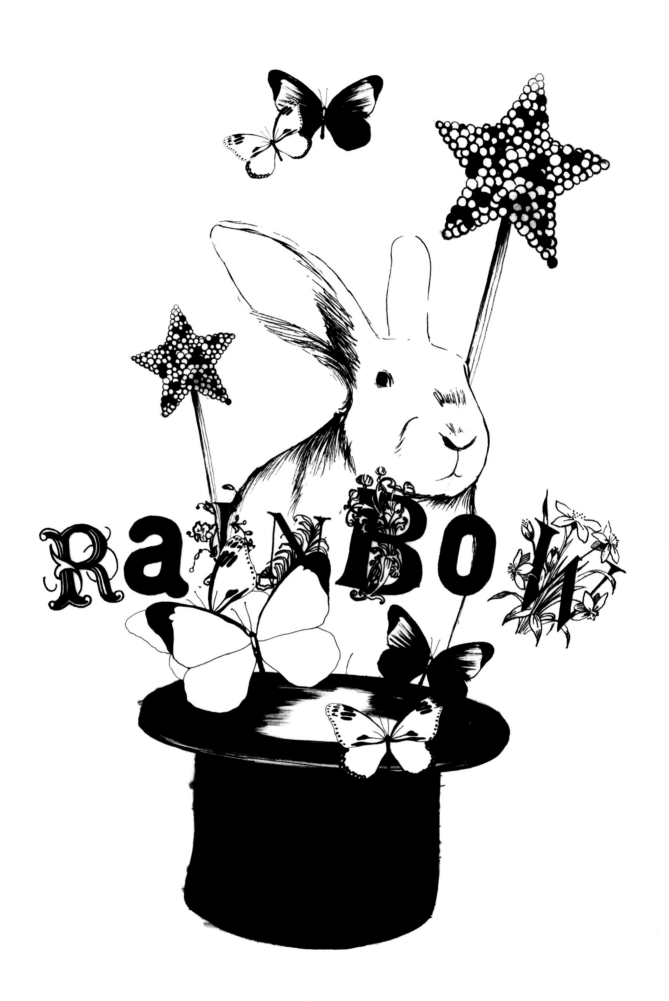

Like the lyrics of a *bolero*, the Rainbow appears after the rain, after the storm. It brings with it a happy dance of promises to be fulfilled. It brings hope to whoever sees it, or, at the very least, an instant of joy. It is a miraculous and short-lived concert.

Science says: decomposition of light in a drop of water.
The colors say: magic trick between us and the sun.

Insistent, science points out: "Optical phenomenon produced by the appearance of a spectrum of light in the sky when the rays of the sun cross small particles of humidity."

The colors counterattack: "Time for fun, end-of-school party and birthday celebration, unbridled merrymaking, happiness just because, hide-and-seek and playing piñata, one, two, three, open your eyes: magic trick for the delight of persons from 1 to 120 years old."

And the discussion ends there.
The most blatant expression of freedom. A flag without a homeland for brave causes. The native land of childhood. Like the sense of humor, it disconcerts dictators and corporate bosses, chess players and computer programmers, lovers of routine and gold diggers . . . Rumor has it that it appeared for the first time after the biblical flood, but all evidence points to this being a self-serving exaggeration.

It is not listed on the Stock Exchange.

Its most famous statement: "One for all, and all for one!"

Tokyo Pop

Rubik

Bubble Valley

Homogenic Palette

Time Machine

Nordic Odyssey

216 Dots

RGB

CMYK

Yummy

Plastidecor

Twister

Big Bang

Lego

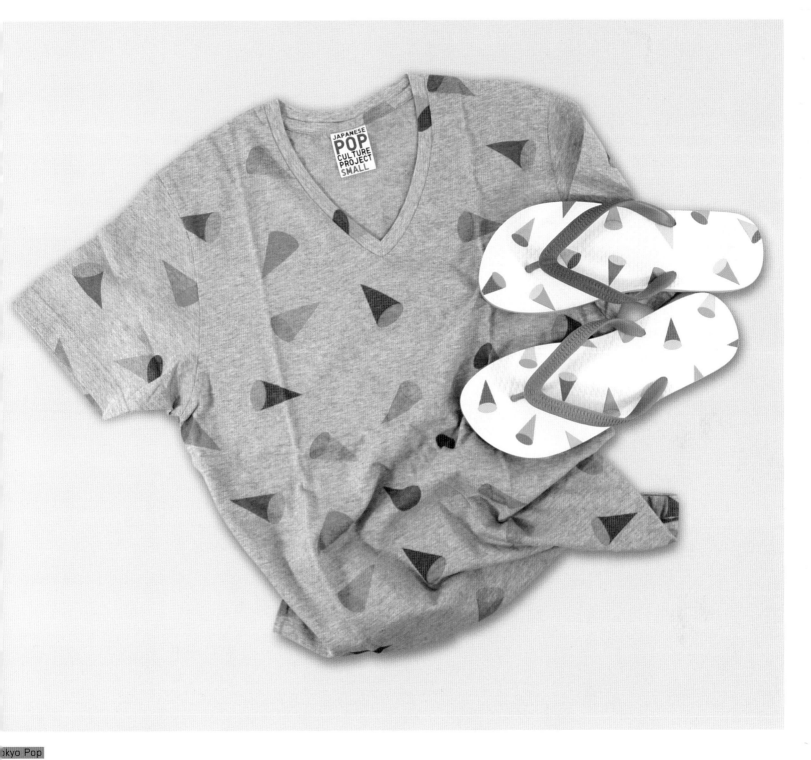

okyo Pop

NICLO

tsuki Kikuchi/Bluemark

ww.bluemark.co.jp

reating new ideas based on the
mplest forms and colors: this is
e intention of the New York store
NICLO. The work of a Japanese
esigner is shown here.

Rubik

Block Coasters

Atsuki Kikuchi/Bluemark

www.bluemark.co.jp

Project for the Tokyo café Inko
consisting of a seven-piece game
of colors with which countless
forms can be created while having
a coffee. The use of color creates a
3D effect.

Bubble Valley

*The Western Edits Part 2*
Stefan Marx/The Lousy
Livincompany
www.livincompany.de

Cover for a single by Isolée. The
design is created and inspired
by watercolor and the use of
multiple colors, though with a single
repetitive form as if different and
varied colors were being utilized.

**STORIES IN MOTION** ▶

Homogenic Palette
AIGA MOVE Poster
Wyeth Hansen, Ryan Dunn
www.wyethhansen.com

Design for a conference at AIGA (American Institute of Graphic Artist) in New York. The colors were cut out from photographs. The design seeks an isometric perspective in order to give a sense of movement and optical illusion to the entire ensemble.

**Time Machine**

If You Could . . .

Luke best/Peepshow

www.lukebest.com

Illustration that responds to the question "If you could do what you wanted to tomorrow, what would it be?" The author travels back in time and meets his parents when they were his age. Color is used to represent the invisible and time travel.

Nordic Odyssey

Etter

Nicolas Burrows, William Edmonds/
Nous Vous

www.nousvous.eu

Sketch that turned into a book
inspired by a trip to Scandinavia.
Graphically, it contains various
literary references. The book is sold
with the music of Vest For Tysso and
Glaciers.

Cover for the album *The Million
Colour Revolution* by the group
The Pinker Tones. It consists of
a typography created with the
combination of brooches of multiple
colors in which the name of the
group can be read.

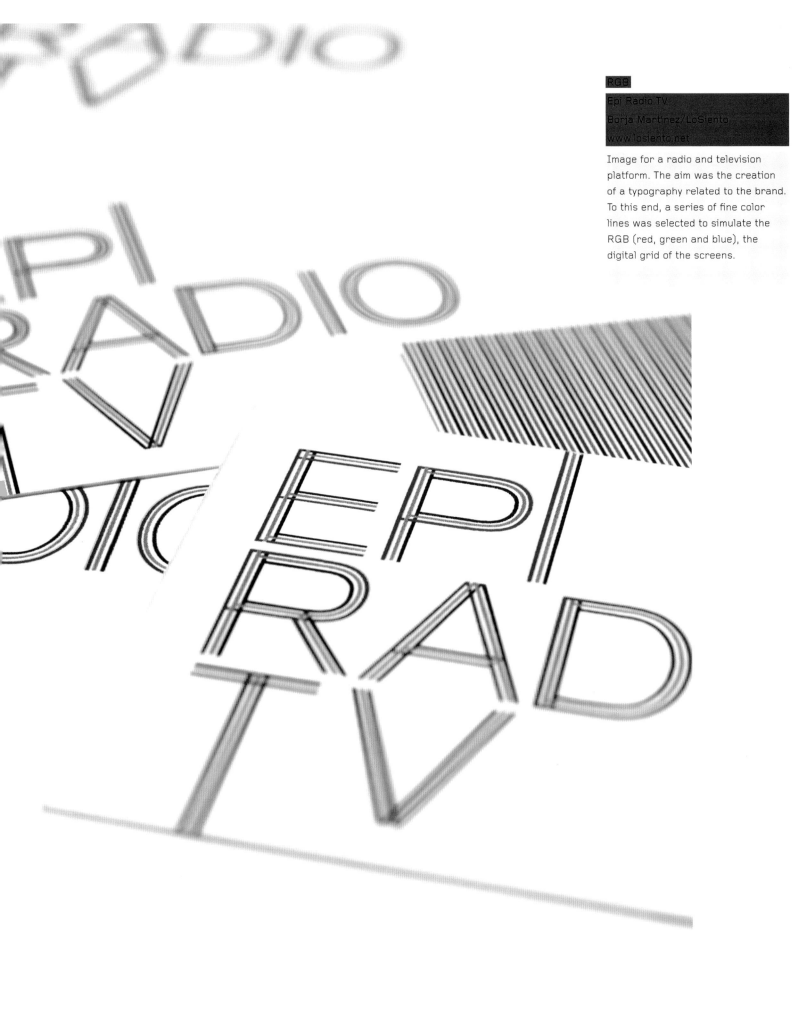

RGB

Epi Radio TV
Borja Martínez/LoSiento
www.losiento.net

Image for a radio and television
platform. The aim was the creation
of a typography related to the brand.
To this end, a series of fine color
lines was selected to simulate the
RGB (red, green and blue), the
digital grid of the screens.

**CMYK**

Gràfiques Ocultes
David Torrents
www.torrents.info

The exhibition "Gràfiques Ocultes" recovered designs from oblivion that had never been seen before. The designer plays with the basic colors of offset printing and the superimposition of colors permitted by this technique.

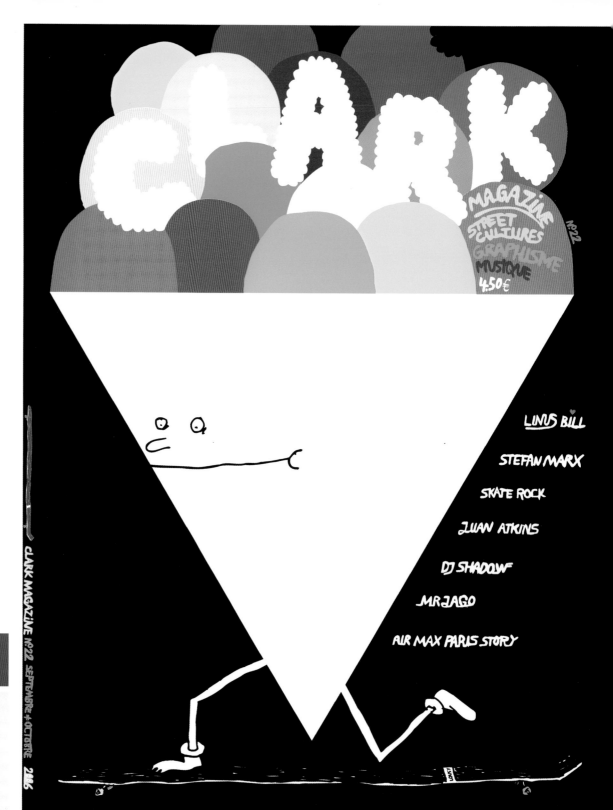

**Yummy**

*Clark Magazine*
Stefan Marx/The Lousy Livincompany
www.livincompany.de

Work for the cover of *Clark Magazine*. With numerous childlike connotations and a simple and fun application of color, this image seeks to arouse as well as provide freshness and originality.

Plastidecor

*Composition* (Collection)
Denastas & Chapus
www.denastasetchapus.com

*Composition* forms part of a collection of books. The covers change with each one, but all the interiors are printed in black and white. The objective is to discover the differences between one book and another.

The Night Will Last Forever
Stefan Marx/The Lousy Livincompany
www.livincompany.de

Inspired by a recording of
Lawrence/Dial Rec in Hamburg,
neon colors were used in the
printing of this T-shirt in which a
shower of color coming from an
unusual rainbow falls over a forest
in the middle of the night.

Hey Yo Square Eyes
Nous Vous
www.nousvous.eu

Images from a video clip of the music group Tiger Force. Their music is chaotic and angular, with the simultaneous inclusion of numerous elements. The colors of the sequence from the video clip, just like the music, are in constant flux.

Lego

BrikaBrak Records
Luke best/Peepshow
www.lukebest.com

Logo and corporate image for a
record company. The design is
based on different geometric forms.
Working with a wide variety of colors
allowed for the utilization of the
image in other mediums, such as
T-shirts.

From Squid Ink
to Burnt Olive

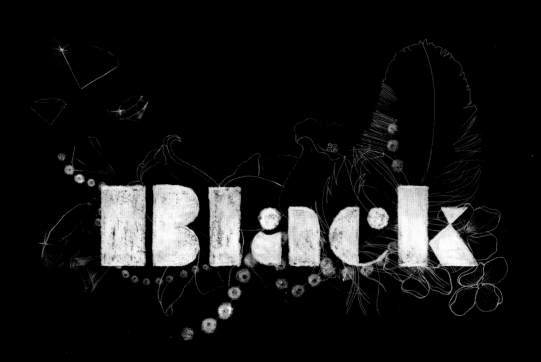

It chooses you, not the other way around. It is the omega of everything: of happiness and sadness, of hope and doubt. . . .

It is eternal and elegant too. It is to the point and an enemy of ambiguity.

When somebody wants to express him or herself but does not know how or wants to rebel but is stifled by too many or a lack of words, all they have to do is come to it in order to redeem themselves, reinvent themselves, come alive again.

One feels secure in its arms.

There exists an ancient unwritten law as old as the universe that prohibits the other colors from speaking about it out loud. And while its presence is permanent, and at times evident, no one in the world of colors has ever had any familiar contact with it.

Voices are extinguished in its path.

An Armenian folk song says: "The color black is a ghost. It cannot be captured. But if it is he who captures us, he will carry us away to the great beyond."

The Impressionists wanted to eliminate it. They strived in vain. Auguste Renoir himself was forced to admit: "It is the king of colors." Years later, Wassily Kandinsky went even further and said what he thought without fear or submission: "Like a nothing without possibility, a dead nothing after the sun burns out. A silence without a future or hope: this is what Black is."

But what is certain is that, ultimately, nobody knows what it is truly like.

Its most famous statement: "I was here before the beginning and will remain after the end."

Squid Ink

Chaos

Caviar

Coal Black

Black Marker

Scratch Paper

Black is Black

Old Cinema

Black Tattoo

Witch

All Blacks

Black Ink

Black Words

Non-light

Grilled Fish

Shadow

Black Coffee

Cutted Typography

Inner Space

Burnt Olive

quid Ink

Love Big Behinds

raig Holden Feinberg,

mar Vulpinari/Begson

ww.begson.com

he strong contrast between white
nd black in this work explores the
onnection between reality and
erception. It was created for the
rofile Intermedia 6 in Bremen in
003. The upside-down heart is an
onic representation of a large behind.

**Chaos**

Feinboigland

Craig Holden Feinberg/Begson

www.begson.com

Drawings that explore the world of Letraset in the form of typographical dreams. Each page was designed by hand in order to give the spectator a coarser, more violent experience and return to graphic design its more amateur dimension.

IM SURROUNDED BY HANDS:

1:50  mt.  0,5  1  2

A 425

i 476

131 FIAT 131 FIAT

U.S.A. Order No.

144pt HELVETICA LIGHT

HAAS

i 317

FIAT Campagnola

FIAT 131

FIAT 131 FIAT 131

**TO AVOID CHOKING KEEP THIS BOOK AWAY FROM BABIES**

Esperalba
Otto&Olaf
www.otto-olaf.com

Corporate image of Esperalba
delicatessen. The use of black and
white for the interior design, bags,
bottles, napkins and labels brings
out the elegance and refinement of
the establishment.

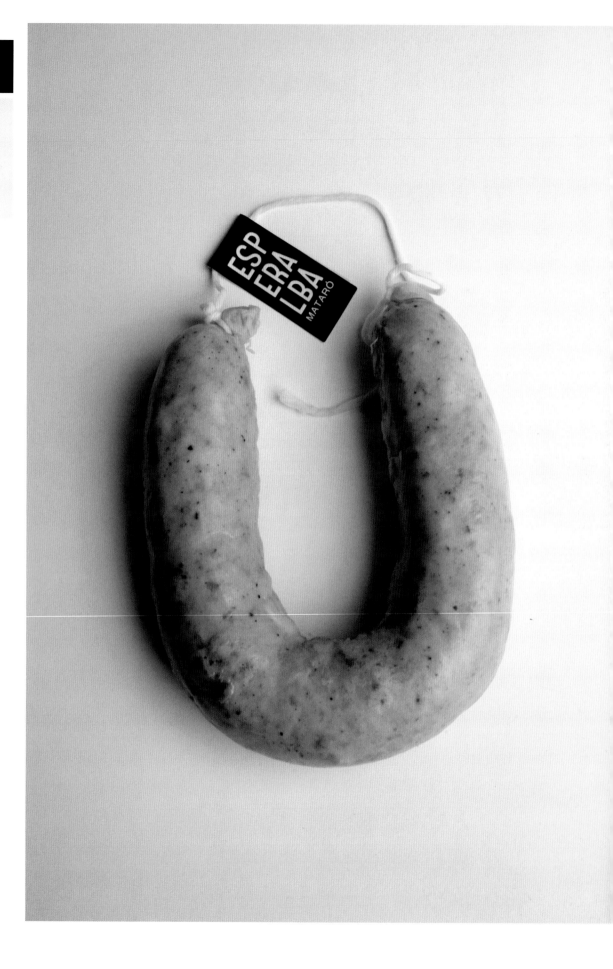

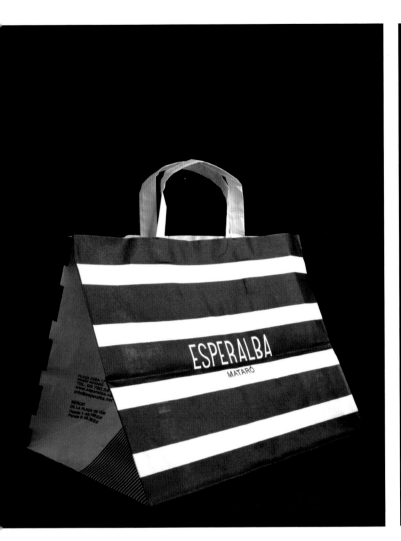

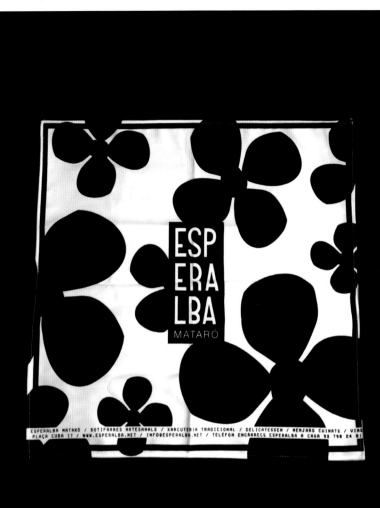

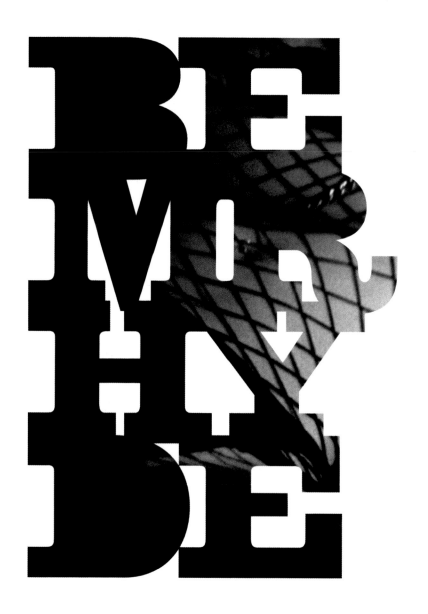

**YOUR NEW STORE** FOR VOYEURISM, FETISHISM, DOMINATION & OTHER AMUSING DEVIATIONS...

BEMRHYDE *FETISH & BDSM GEAR* · 35 LEXINGTON STREET · SOHO W1 · TEL: 020 7608 2011 · FAX: 020 7250 4107 · WWW.BEMRHYDEBDSMGEAR.CO.UK

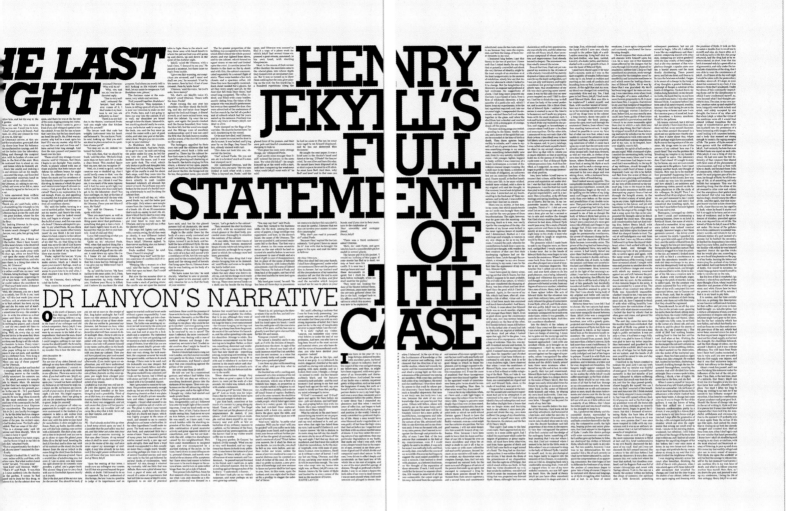

Illustrations for the fall/winter
2007/08 collection of a brand of
clothing. The use of black against
a white background gave rise to
the creation of twisted and unreal
figures reminiscent of a bestiary.

Scratch Paper

Central Saint Martins BA Graphic
Design Catalogue 2007
Many Designers
www.mattbucknall.co.uk

Catalog of the work of recent
graduates of Central Saint Martins
College of Art and Design BA
Graphic Design 2007. The use of
texture and the juxtaposition of color
and different materials are constant
in this publication.

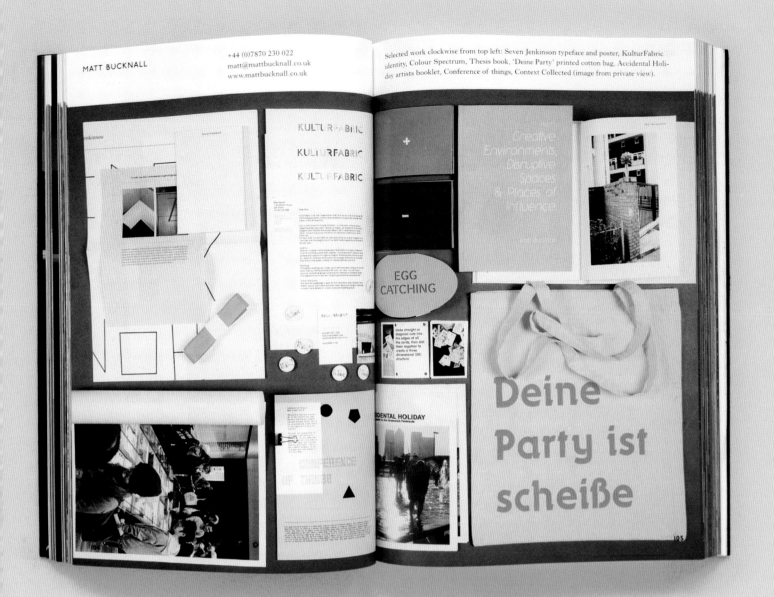

MATT BUCKNALL
+44 (0)7870 230 022
matt@mattbucknall.co.uk
www.mattbucknall.co.uk

Selected work clockwise from top left: Seven Jenkinson typeface and poster, KulturFabric identity, Colour Spectrum, Thesis book, 'Deine Party' printed cotton bag, Accidental Holiday artists booklet, Conference of things, Context Collected (image from private view).

YUI SUGIYAMA +44 (0)7811 361 096
yui_sugiyama.is@googlemail.com

HYPER!! HYPER!! HYPER!! Thank you everyone for all the inspirations!!
Would you like some cake? I'll share this time!

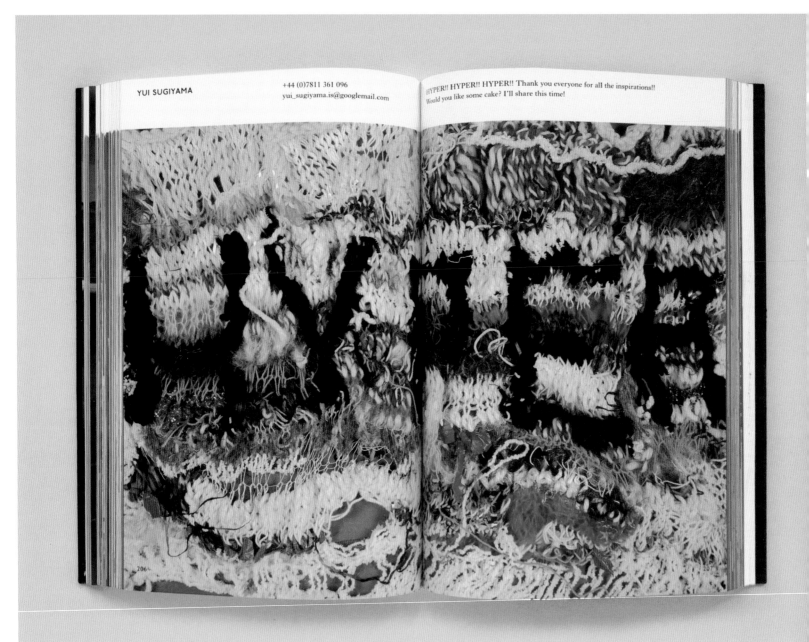

## A DESPERATE MELTING LOVE STORY

I KNEW AN AMANITA MUSCARIA, AND I DIED LOVING HER.

**Black is Black**

Amanita
Alessandro Maffioletti/Alvvino
www.alvvino.org

White and black for an illustration from a series designed for *Robot Magazine*, a digital weekly publication based in Barcelona. The drawing is of the *Amanita muscaria* mushroom.

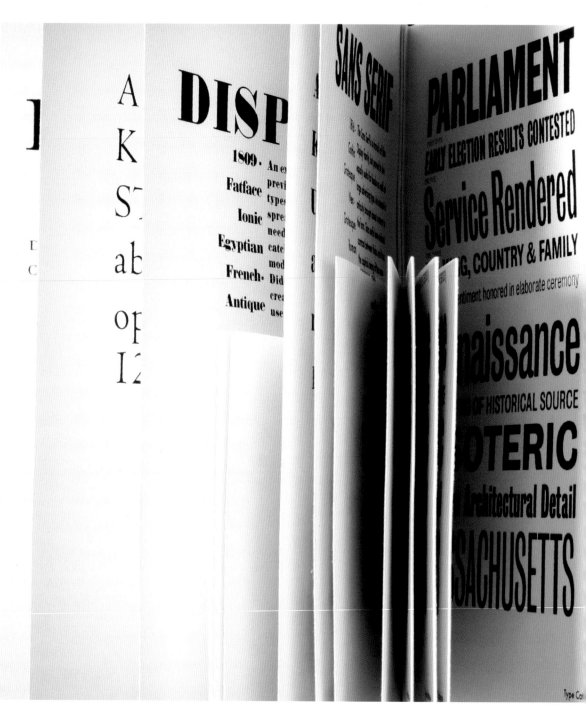

**Old Cinema**

Genealogy of Type

Hollie Lubbock

www.hollielubbock.co.uk

The colors used for this project
are the fruit of the CMYK color
process. The use of this process
refers to the printing and the
manner in which the colors are
constructed in reproductions.

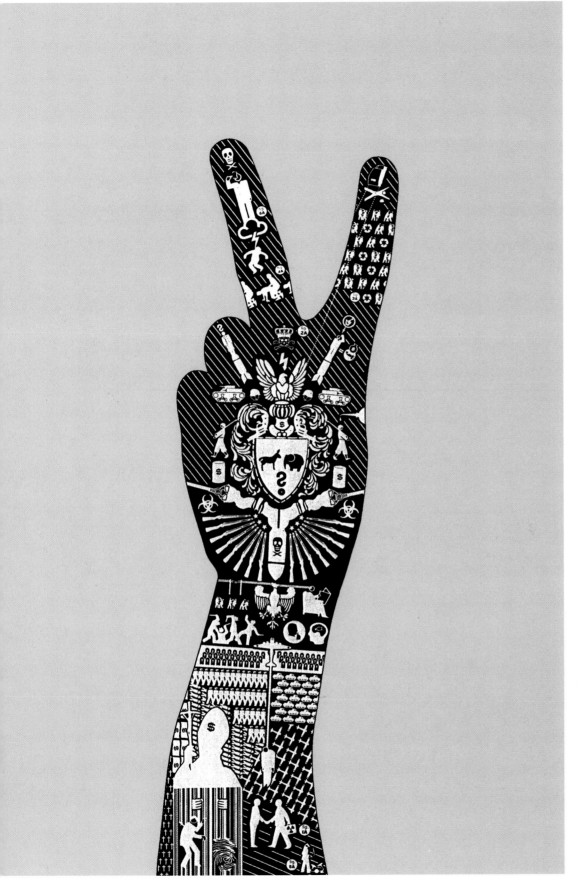

Work for the political propaganda
show *One Club of New Cork*. The
creators were granted total liberty.
The selection of such a minimalist
palette of colors had as an objective
achieving the largest impact possible
on the memory of the spectator.

Witch

*Pocket Sized*
Nous Vous
www.nousvous.eu

This publication takes space as
its central theme and space travel
as an ultimate objective. Black
and silver make reference to the
universe. Some 30 collaborators
reflect on space in this issue.

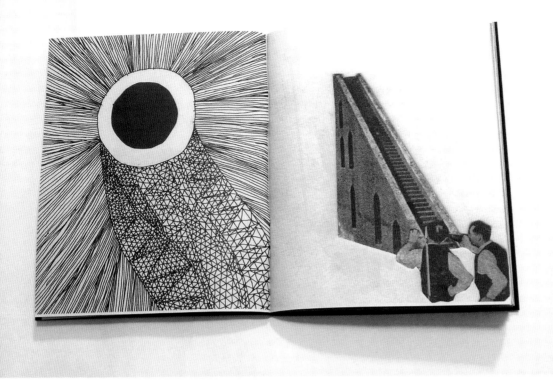

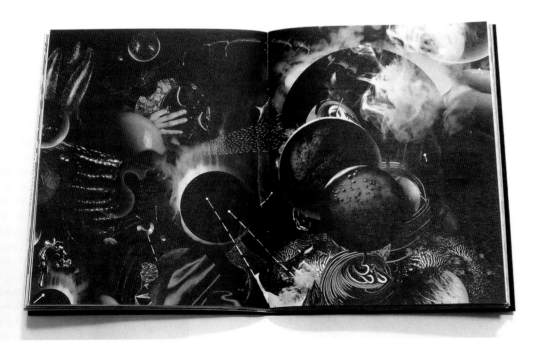

**#9 Hours, March 2007**

e Creato

24

**All Blacks**

*The Creator Studio*
Estudio Rosa Lázaro/La habitación
ediciones
www.rlazaro.com

*The Creator Studio* is a Barcelona art and design publication. As a cohesive element of the visual sense color plays a fundamental role. To strengthen it, black has been used for many of the backgrounds.

I went inside. And there were no survivors.

**ROUTINES by Benoît Guillaume.** It was not that long ago that Benoît Guillaume left the world of fluorescent lights, endless redundancy and monthly paychecks in favor of his espresso machine at home, time being at his mercy, and financial uncertainty. Those six (not so far removed) years during which he worked in the offices of web design companies were his inspiration when depicting a workday behind closed doors. Benoît Guillaume studied art and architecture in Paris and in 1998 landed in New York, where he would study at the Parsons School of Design. Following the years of graphics and animation for websites, he established himself as a freelance illustrator in Paris. His serious passions are comics and his self-declared "senseless films." He has published a comic book and two flip books, he has also worked on projects for Bic, SNCF, Arte Radio and the Festival de Marne.

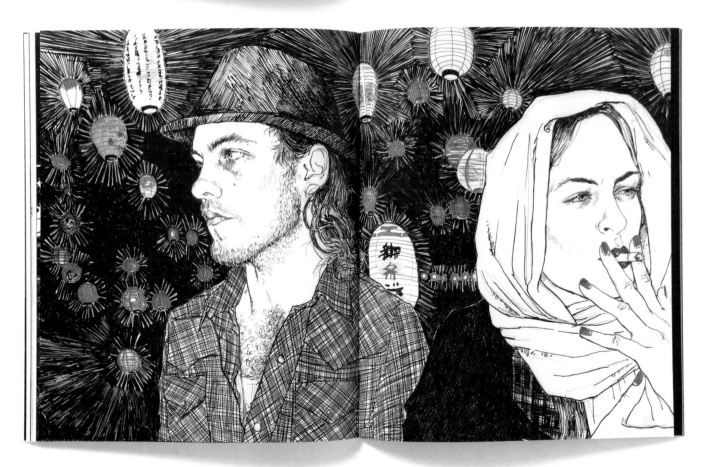

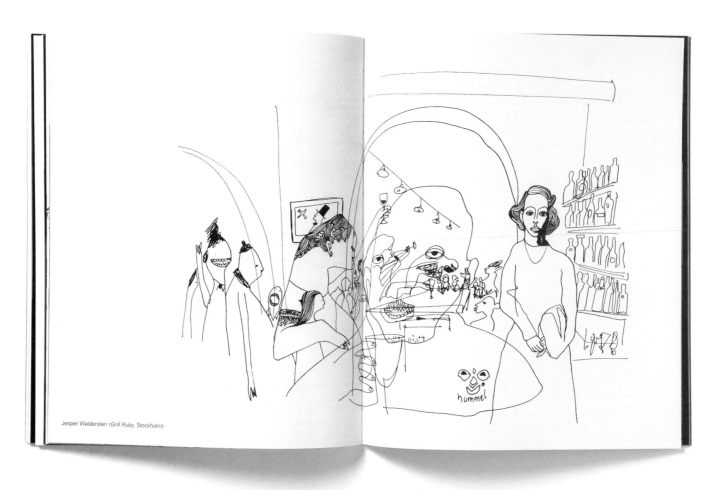

Jesper Waldersten (*Grill Ruby*, Stockholm)

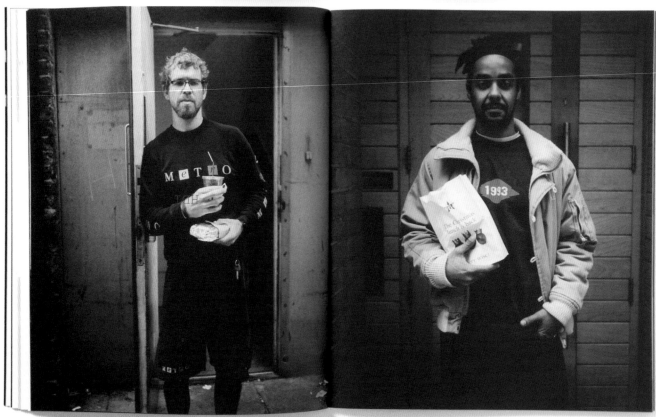

Black Ink

Black Invitation

David Guarnieri/Paprika

www.paprika.com

Invitation for the party Noir, the second largest exhibition to date in the art gallery Commissaires, in Montreal. Black text on white paper with a layer of silk; variations exclusively in the light.

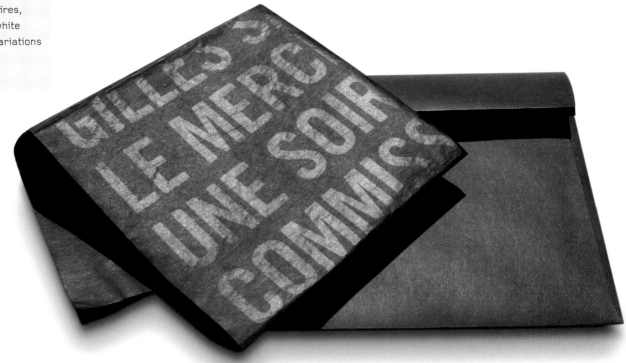

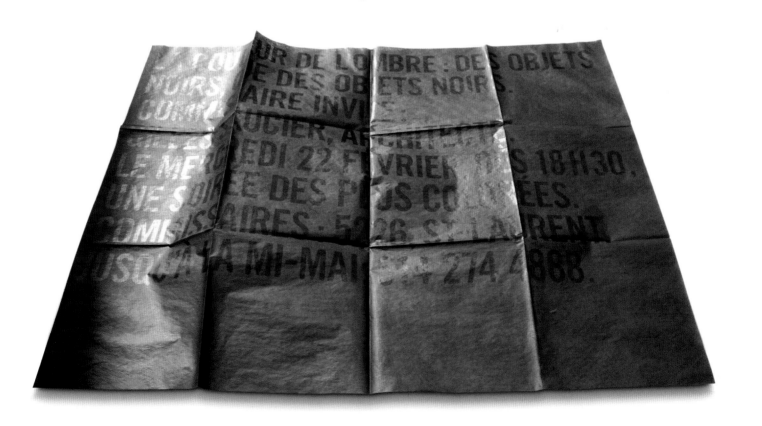

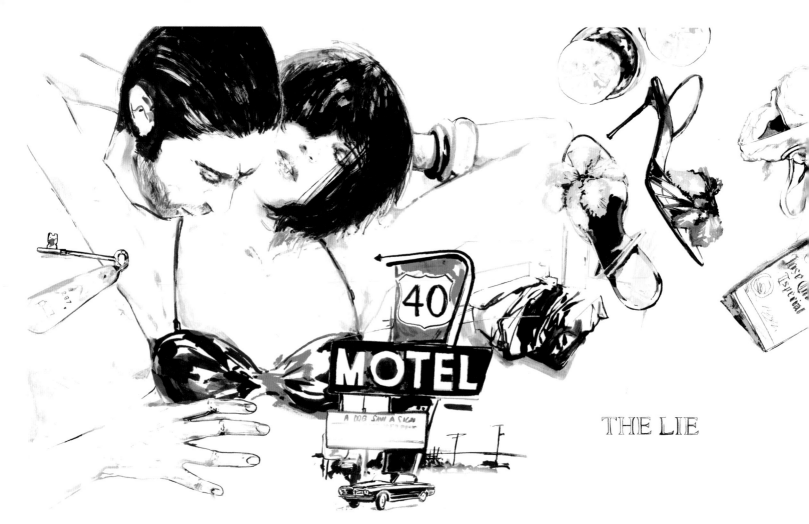

THE LIE

**Black Words**

Four Words for a Secret
Berto Martínez
www.bertomartinez.blogspot.com

Illustrations for an issue of *Creators Magazine*. Color was almost completely abstained from in order to situate the illustrations in a film-noirish environment. "Truth," "lie," "denunciation," and "confession" are the four words around which this work revolves.

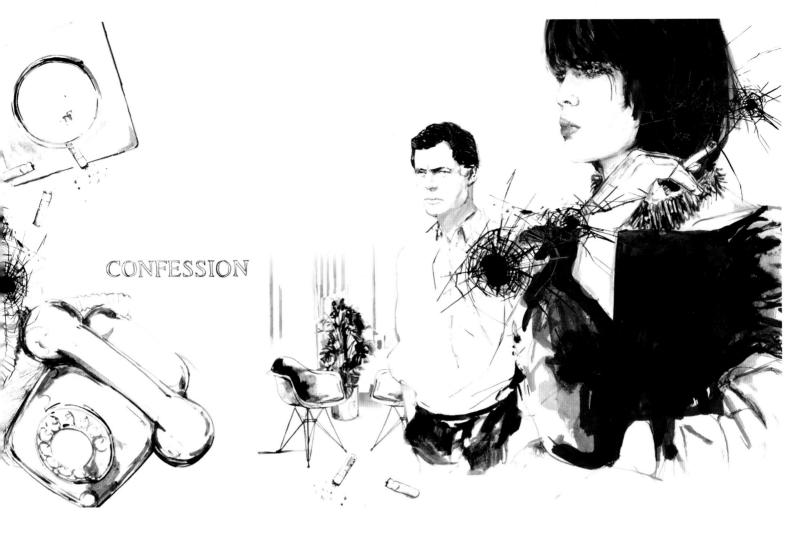

CONFESSION

Exhibition of the toy instruments of Pascal Comelade in the Toy Museum of Catalonia. Poster, catalog and drawings reminiscent of a child's doodling: a metaphor for the toy instrument played by an adult.

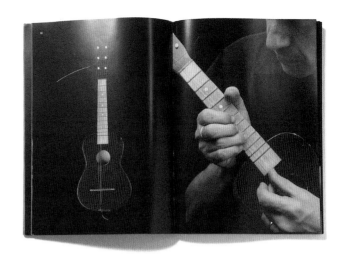

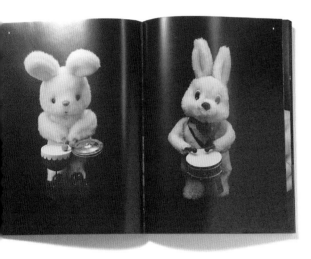

**26.01.2007**
# LET THE SUNSHINE IN AGAIN. AQUARIUS PARTY.

DELIRIUM MASKED PARTY

:: **MUSIC.VISUAL** ::
LUCHINO DJ
TANTOTEMPO
CRTLZ

**ATMOSPHERE LIVE** - VIA LUDOVICO MOTEGANI 64
INFO: PARIDE 3386477658

**Grilled Fish**

Aquarius Party: Let the Sunshine in Again
Alessandro Maffioletti/Alvvino
www.alvvino.org

Series of flyers for a party given at the end of January 2007 to celebrate the entrance of the Age of Aquarius. Two colors, white and black, were used for a series of hand-drawn illustrations.

# 26.01.2007
# LET THE SUNSHINE IN AGAIN. AQUARIUS PARTY.

DELIRIUM MASKED
PARTY

:: MUSIC.VISUAL ::
LUCHINO DJ
TANTOTEMPO
CRTLZ

**ATMOSPHERE LIVE** - VIA LUDOVICO MOTEGANI 64
INFO: PARIDE 3386477658

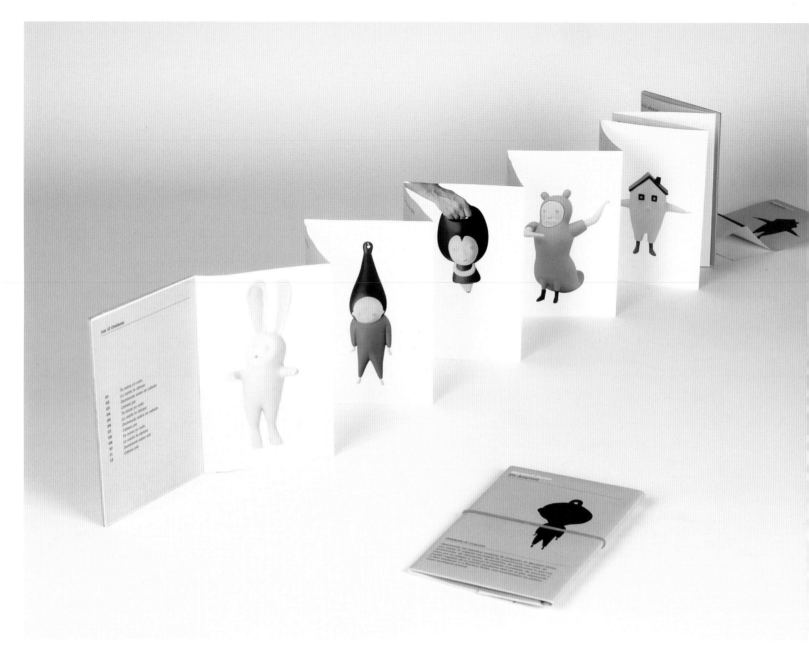

*Els Adoptats*
Borja Martínez/LoSiento
www.losiento.net

Catalog of sculpture pieces by the illustrator Meritxell Duran. The same pastel colors of the sculptures were used. The idea was to have a small, easy-to-read, fold-out catalog.

**Meritxell Duran**
*Els Adoptats*

**Criaturas** de compañía

Observando las extrañas criaturas de compañía de Meritxell Duran, uno siente la urgente necesidad de comunicarse con ellas, de acariciarlas, de abrazarlas, de mecerlas, de explicarles lo que nos pasa por la cabeza o, cuando la ocasión lo permite, de sacarlas a pasear cogidas de la manita (momento éste en el que, superando a Pere Gimferrer y a Norman Bates, nos mostraremos en público como realmente somos).

**Black Coffee**

Gorišek-Lazar

Vladan Srdic/Thesign, Studio 360

www.thesign.co.uk

The image of this album by the duo
Gorišek-Lazar, a mix of classical
music and jazz, was achieved with
a noble neutral gray. Basic graphic
elements create a visual and
emotional impact.

# 3
# 3
## tubelight

Tubelight is een onafhankelijk recensieblad en biedt korte, kritisch geschreven recensies over met name kleine presentaties op het gebied van de beeldende kunst in Nederland. Tubelight is gratis en wordt verspreid via galeries en kunstinstellingen. Tegen een vergoeding van euro 16.00 per jaar ontvangt u het blad thuis.

De redactie van Tubelight staat open voor reacties en bijdragen.

redactieadres
Witte de Withstraat 53
3012 BN Rotterdam
t/f 010 213 09 91

# 24

Arnout Noordegraaf, Tarf (2002)

## tubelight

Tubelight is een onafhankelijk recensieblad en biedt korte, kritisch geschreven recensies over met name kleine presentaties op het gebied van de beeldende kunst in Nederland. Tubelight is gratis en wordt verspreid via galeries en kunstinstellingen en door middel van *controled circulation* onder professionals op het gebied van de beeldende kunst. Overige belangstellenden kunnen tegen een vergoeding van euro 16.00 per jaar het blad thuis ontvangen.

De redactie van Tubelight staat open voor bijdragen.

redactieadres
Witte de Withstraat 53
3012 BN Rotterdam
t/f 010 213 09 91

## Cutted Typography

*Tubelight* Magazine 2002-2005
Stout/Kramer
www.stoutkramer.nl

Image of a contemporary art magazine from the Netherlands. White and black take center stage. The publication seeks to communicate strength and character through the clear use of typography.

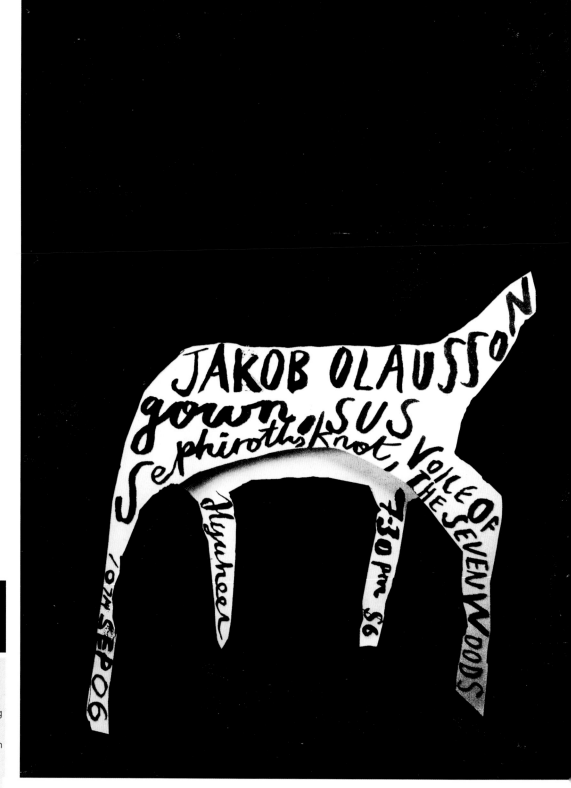

Inner Space

Voice of the Seven Woods
(Jakob Olausson)

Rick Myers

www.footprintsinthesnow.co.uk

Poster entitled "Voice of the
Seven Woods" which explores
the possibilities of an almost
monochromatic style for transmitting
emotions, even though no color is
involved. The model of the illustration
is a paper miniature with hand-
painted letters.

Burnt Olive

Dany Schnyder
Erich Brechbühl/Mixer
www.mixer.ch

Business card of percussionist Dany Schnyder. The card is printed by hand in black on the front and back. Instead of paper, it is made with drum skin.

DEDICATED TO
PABLO, TEO and NICO

Thanks to

Marta, Vicky, Roser, Francesca, Patricia,
Emma, Anja, Felipe, Nacho, Adriana, Laieta.